T0043145

Illustrated by Ella McLean
Edited by Jocelyn Norbury
Designed by Jack Clucas
Cover design by Lee–May Lim and John Bigwood

First published in Great Britain in 2022 by LOM ART,
an imprint of Michael O'Mara Books Limited,
9 Lion Yard, Tremadoc Road, London SW4 7NQ

W www.mombooks.com/lom
f Michael O'Mara Books
🐦 @OMaraBooks
📷 @lomartbooks

A CIP catalogue record for this book is available from the British Library.

ISBN: 978-1-912785-72-8

1 3 5 7 9 10 8 6 4 2

This book was printed in China.

Introduction

Drawing is supposed to be fun, but it's easy to get bogged down wondering what to draw and how to draw it. This book is packed with projects that are designed to take the pressure off.

To complete each drawing, follow the steps. Each new line is in a darker colour, so you can see what to draw at each stage.

To help with spacing, proportions and placement, the steps use construction lines. Make these lines faint so you can rub them out easily when your drawing is complete.

You will find tips and instructions throughout the book for extra help, but don't worry if you just want to get drawing as the pictures will give you all the information you need to complete the projects perfectly.

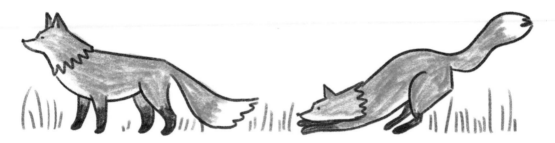

Mice, using simple lines

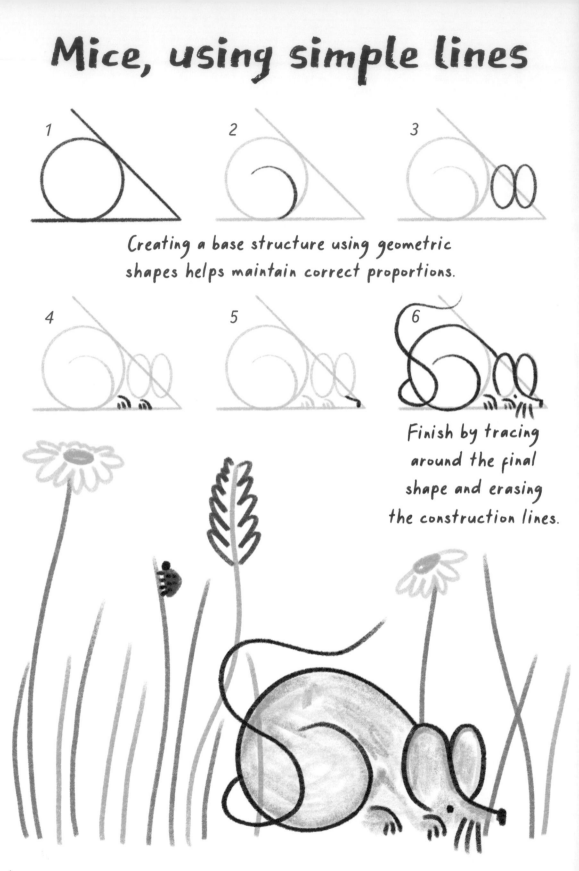

Creating a base structure using geometric shapes helps maintain correct proportions.

Finish by tracing around the final shape and erasing the construction lines.

Start with your base shapes ...

... before adding details.

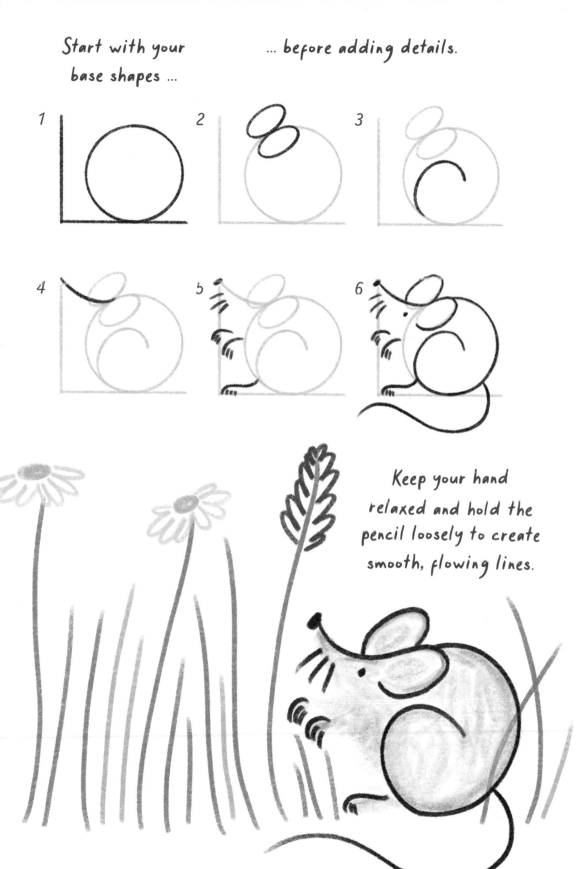

1 2 3

4 5 6

Keep your hand relaxed and hold the pencil loosely to create smooth, flowing lines.

A flock of chickens

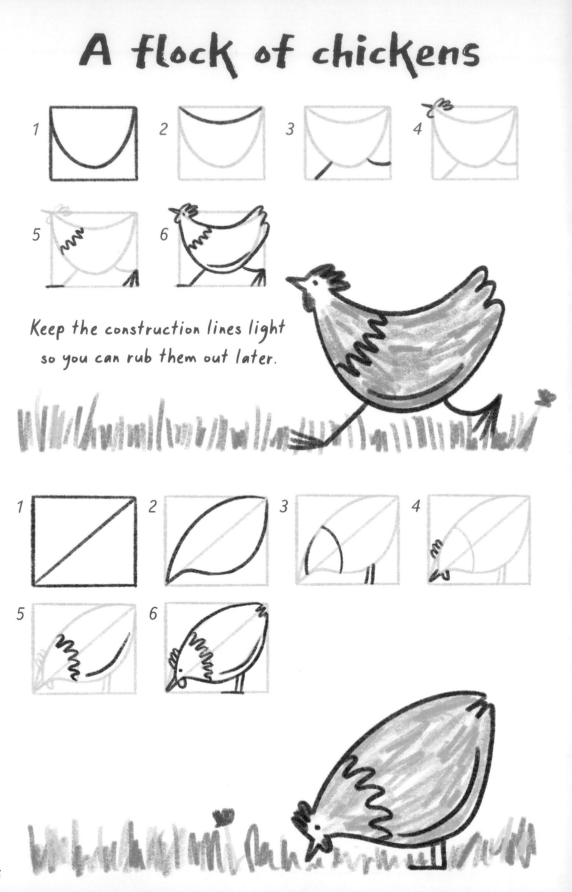

Keep the construction lines light
so you can rub them out later.

Other shapes work, too.

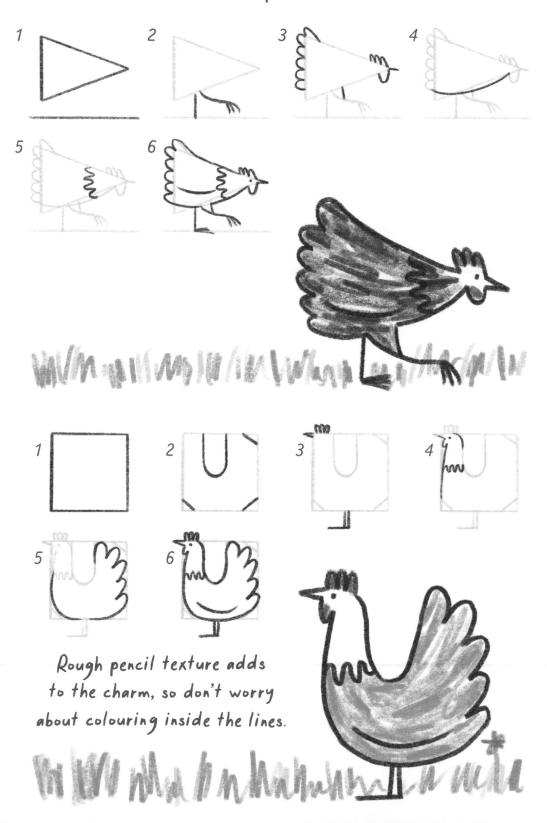

Rough pencil texture adds
to the charm, so don't worry
about colouring inside the lines.

Pig poses

In profile

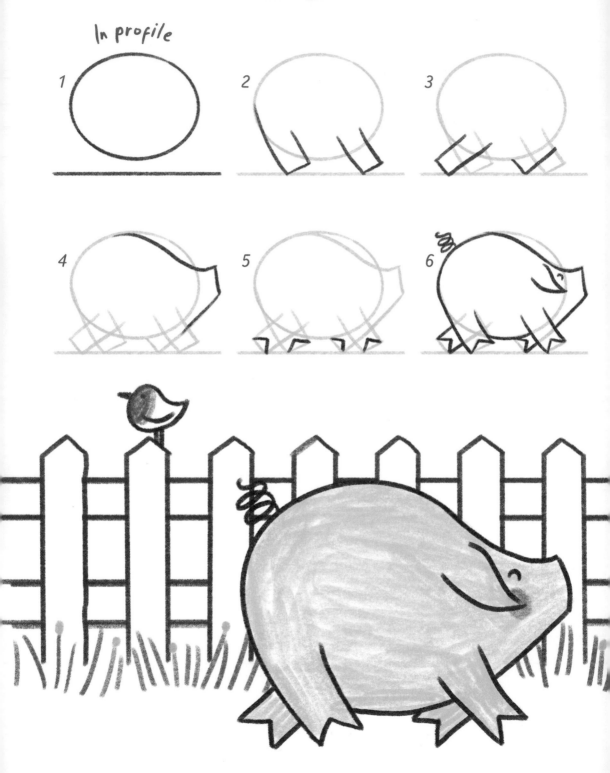

1

2

3

4

5

6

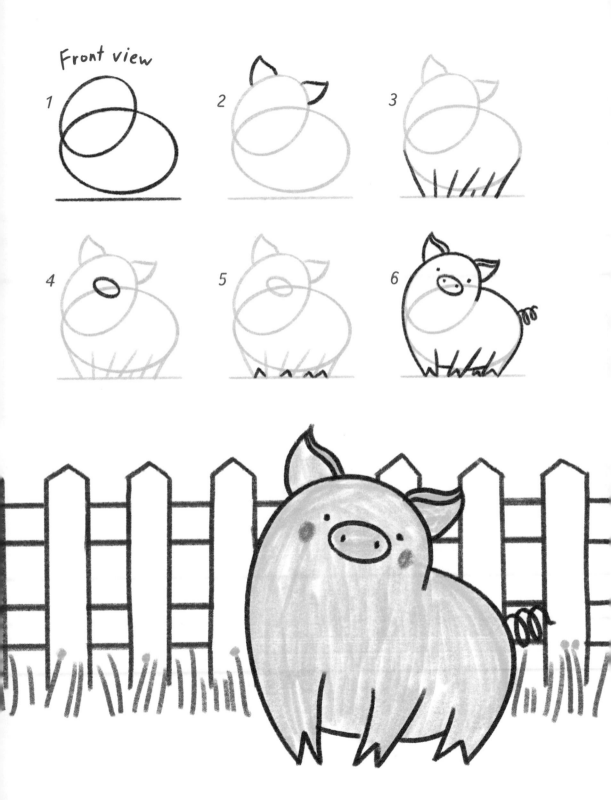

Front view

1

2

3

4

5

6

All at sea

1 Draw a semi-circle.

2 Add a small circle.

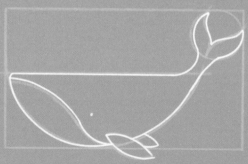

3 Draw a flipper, a wishbone shape for the tail and a curved line for the body.

4 Trace around the outline to finish the tail, then add an extra flipper and the eye.

There's nothing fishy about these deep-sea doodles!

Fish

1

2

3

4

5

6

To create the shell pattern,
start by drawing a single line
of hexagons down the centre
of the shell before adding
the rest of the shapes.

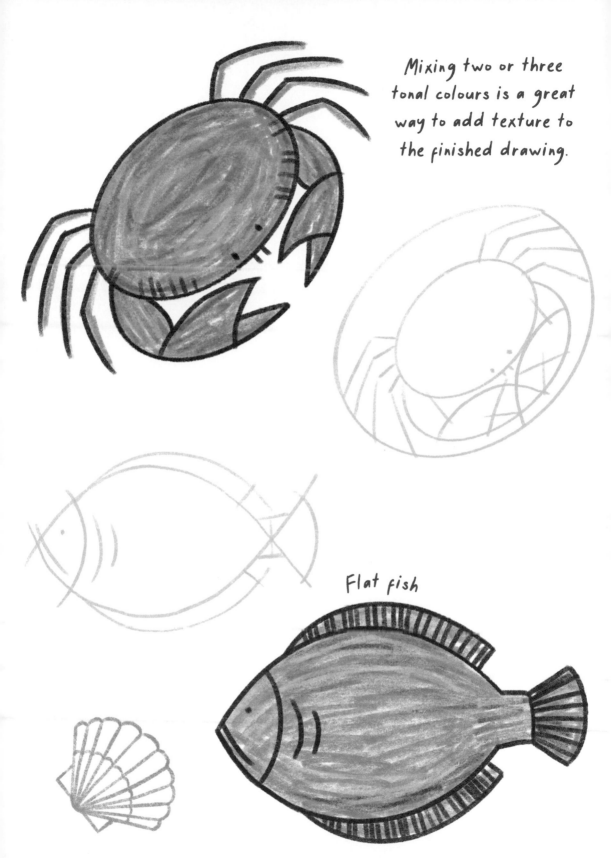

Mixing two or three tonal colours is a great way to add texture to the finished drawing.

Flat fish

13

Start by drawing the pelican's distinctive beak.
Did you know that the 'mouth pouch' is called a gular?

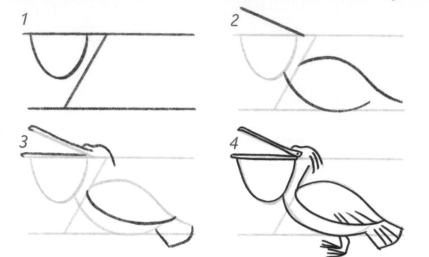

The puffin's upright posture and facial
markings make it stand out in a crowd.

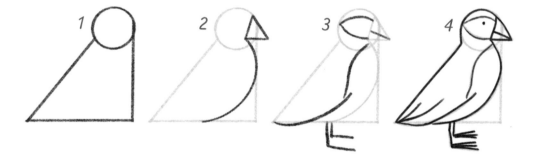

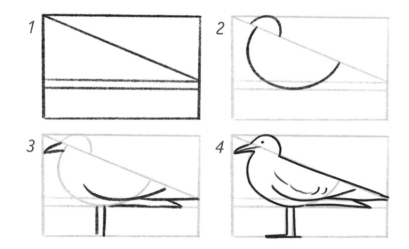

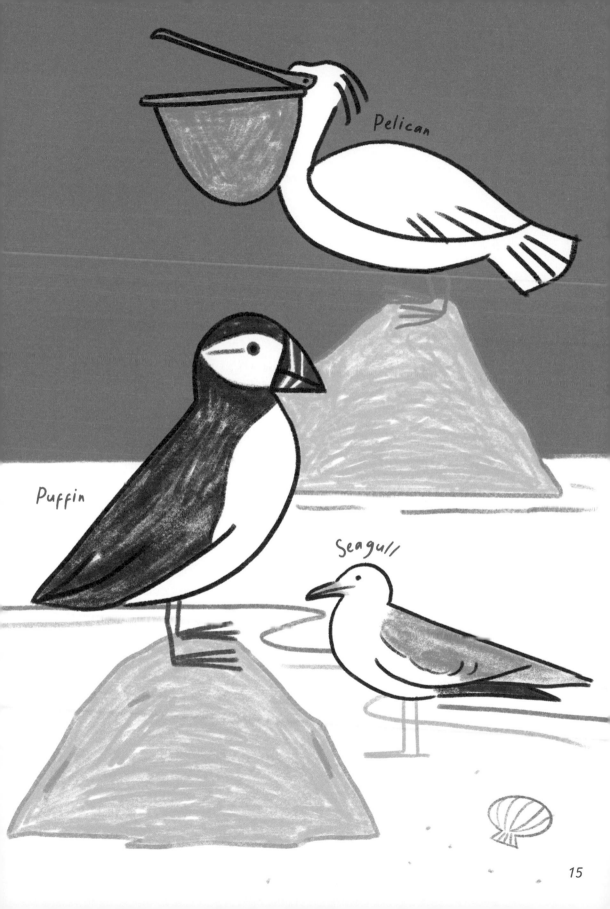

Pelican

Puffin

Seagull

Perfect pets

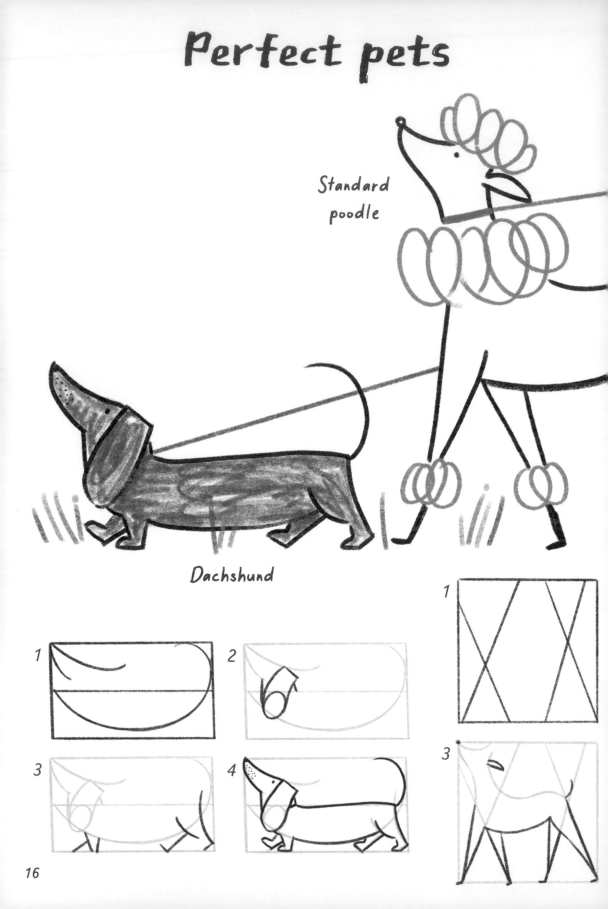

Standard poodle

Dachshund

1

2

3

4

1

3

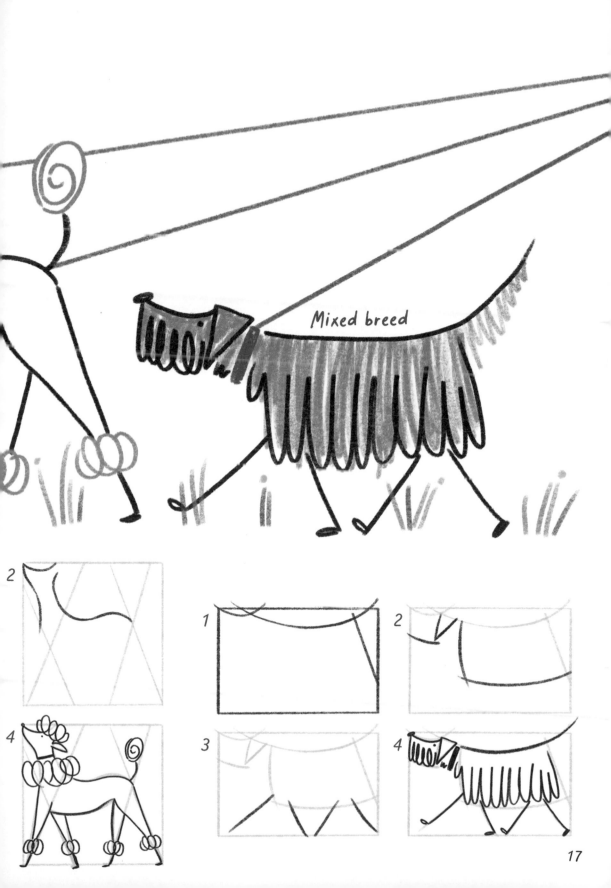

Mixed breed

2

1

2

4

3

4

Side-on Scottie dog

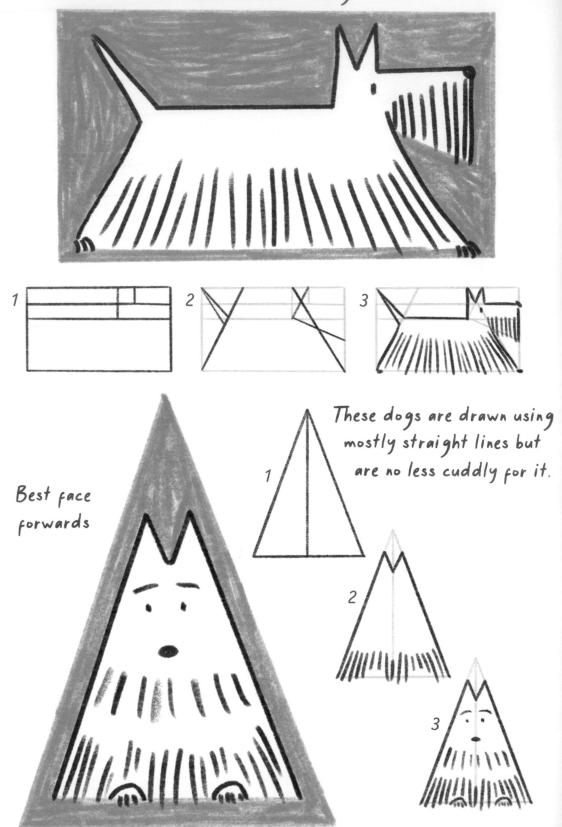

1

2

3

Best face
forwards

1

These dogs are drawn using
mostly straight lines but
are no less cuddly for it.

2

3

Curled-up kitten

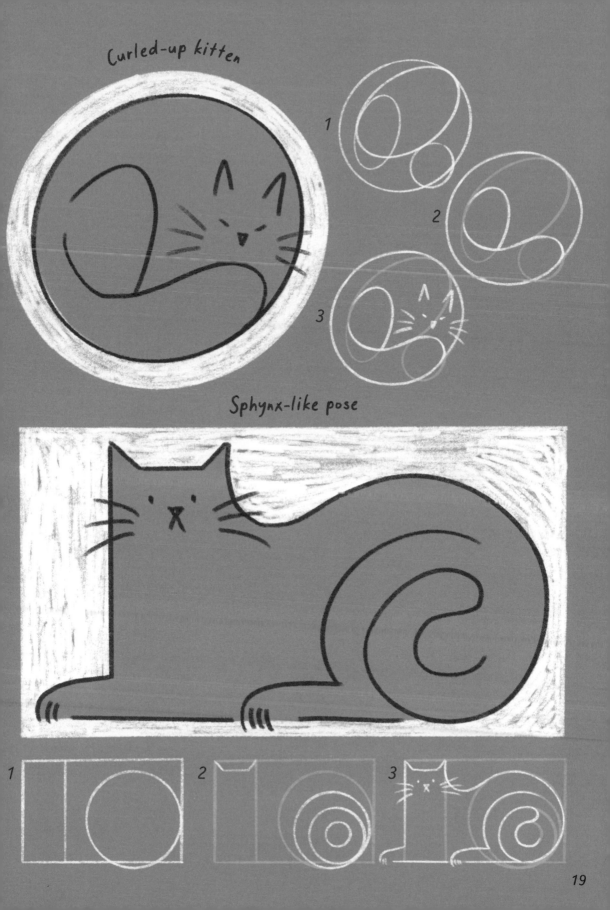

Sphynx-like pose

Tropical birds

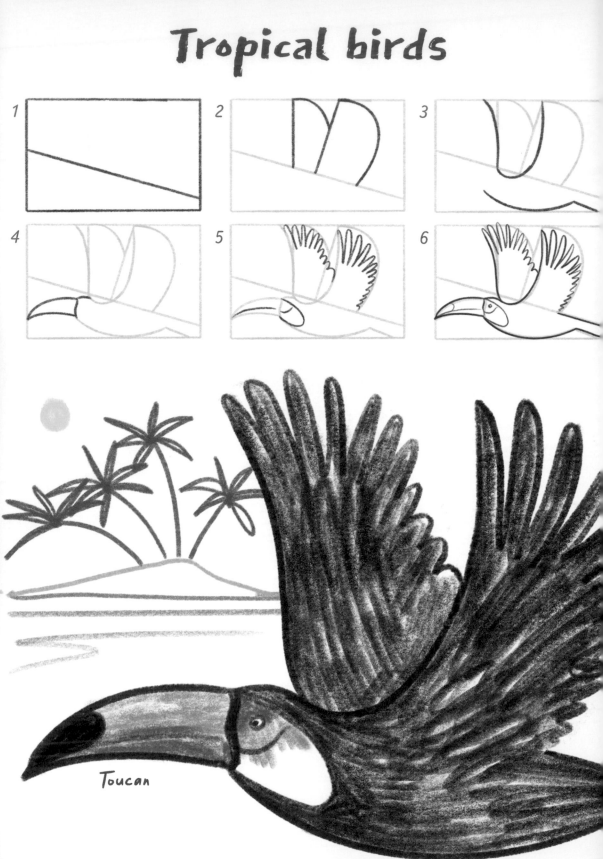

Toucan

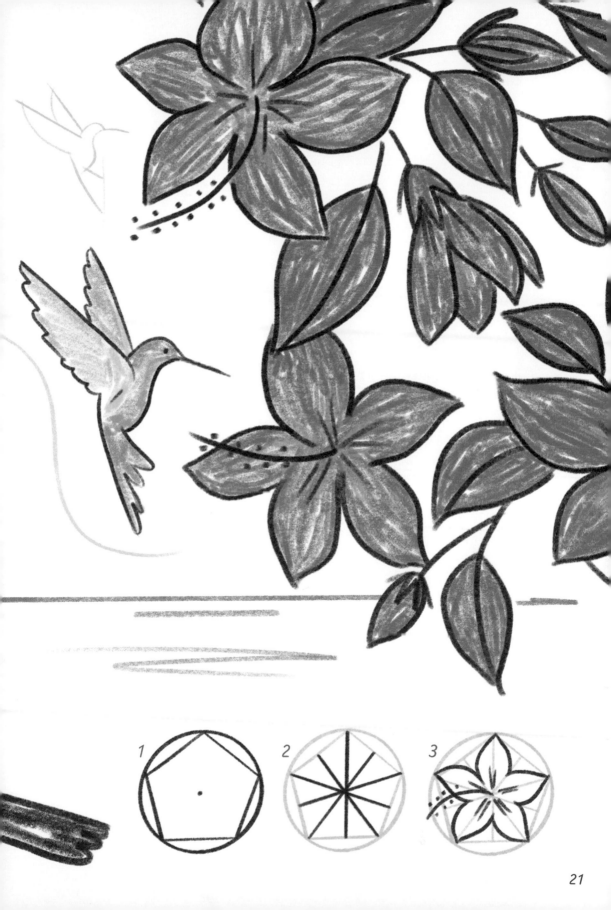

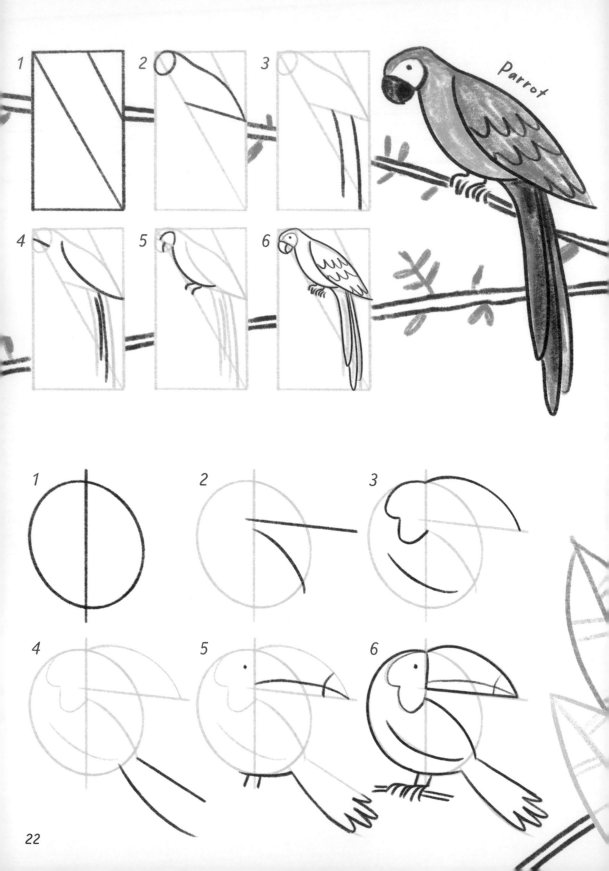

1

2

3

Parrot

4

5

6

1

2

3

4

5

6

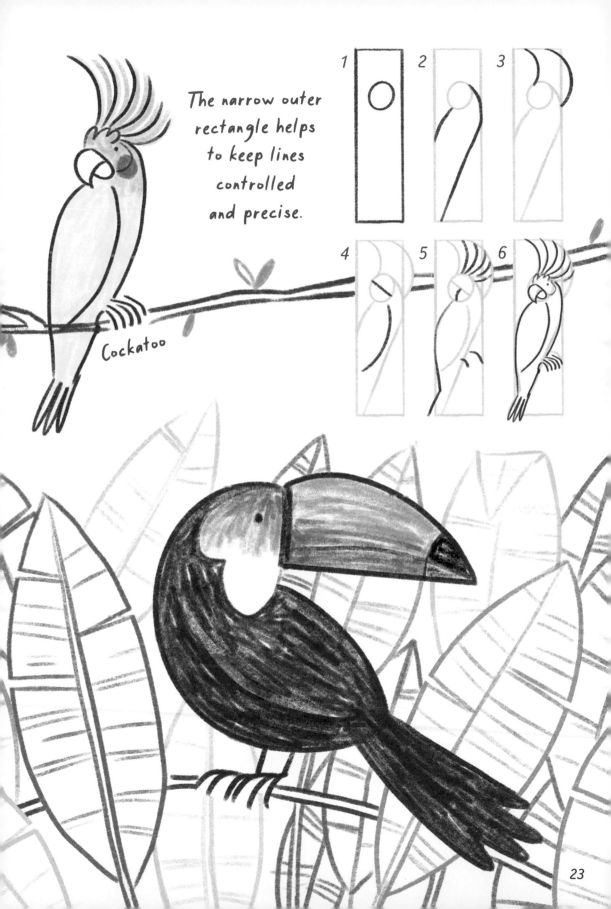

The narrow outer rectangle helps to keep lines controlled and precise.

1 2 3

4 5 6

Cockatoo

Woodland wonders

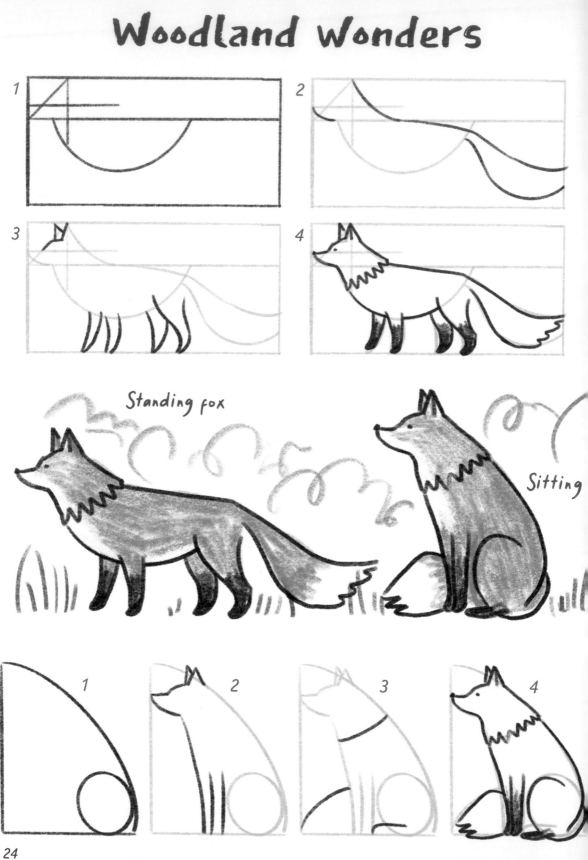

1

2

3

4

Standing fox

Sitting

1

2

3

4

Starting with a solid external shape that can be rubbed out at the end gives a solid foundation to your drawing.

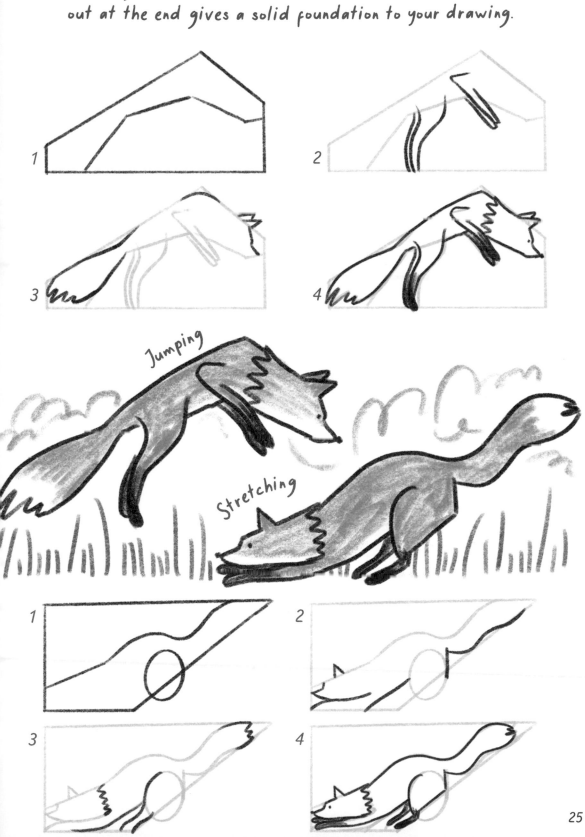

1

2

3

4

Jumping

Stretching

1

2

3

4

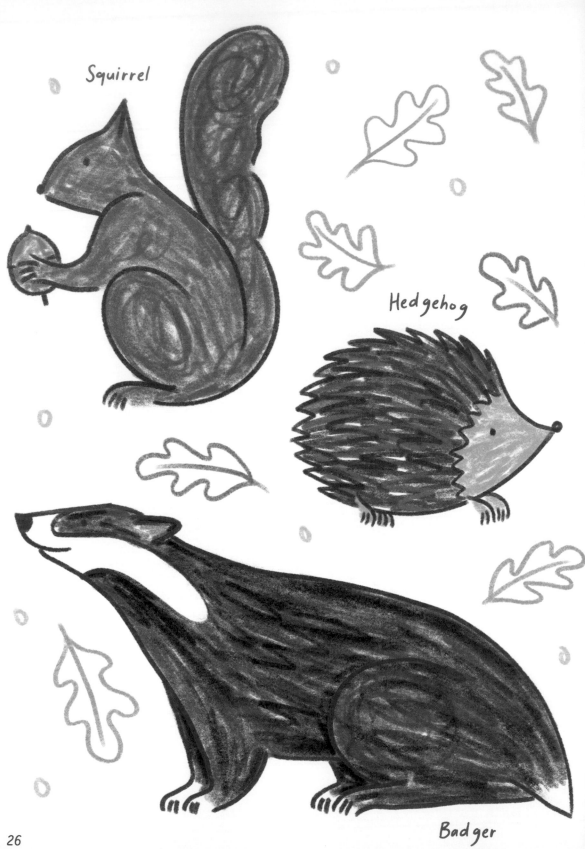

Squirrel

Hedgehog

Badger

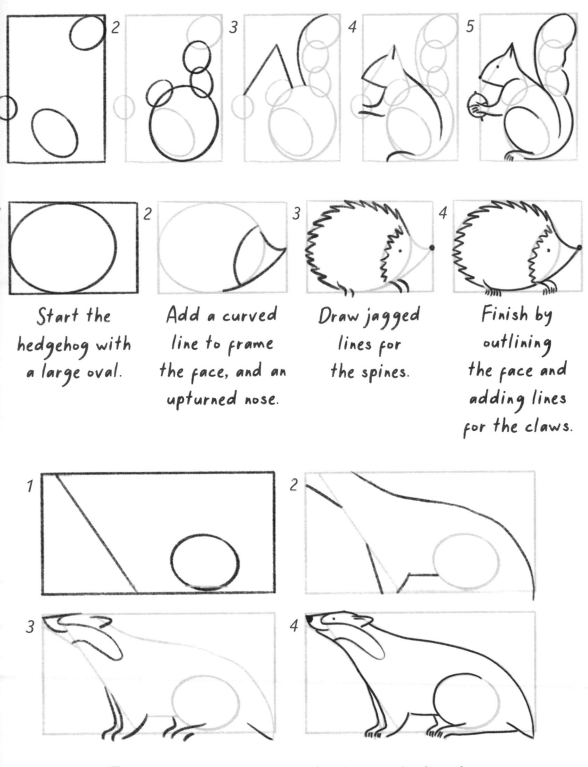

Start the hedgehog with a large oval.

Add a curved line to frame the face, and an upturned nose.

Draw jagged lines for the spines.

Finish by outlining the face and adding lines for the claws.

The construction lines inside the finished badger will be disguised when you add colour.

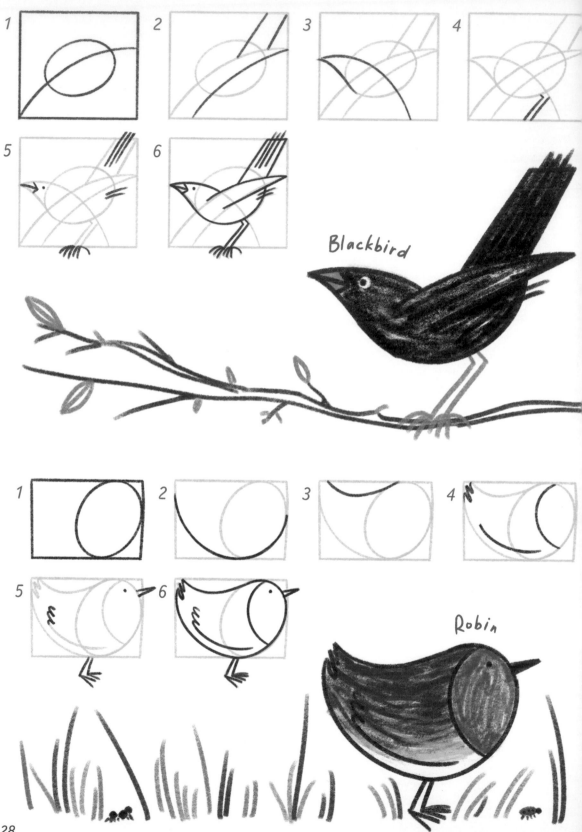

1

2

3

4

5

6

Blackbird

1

2

3

4

5

6

Robin

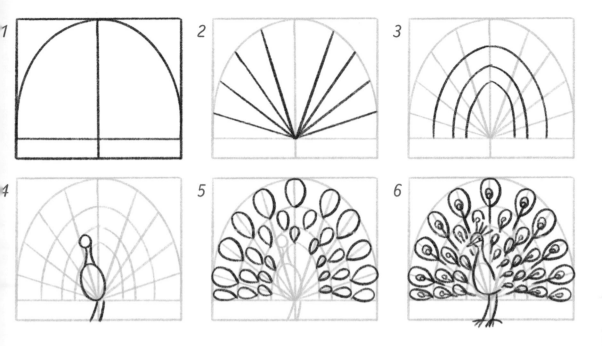

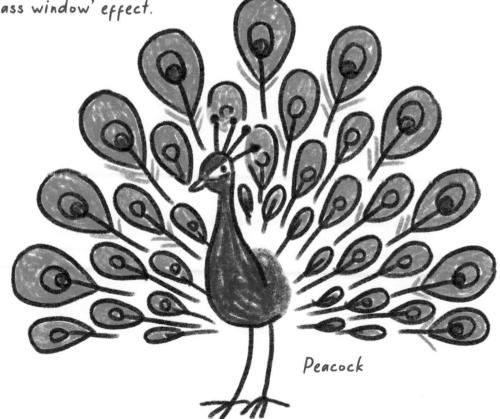

Finish the peacock's tail in jewel colours for a beautiful 'stained-glass window' effect.

Peacock

 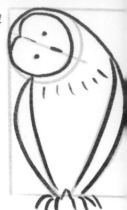

Start with a circle and a curved line.	Add three more lines to complete the body and wings.	Draw dots for the eyes and guidelines for the face.	Finish with a heart-shaped face, nose and lines for the neck and feet.

With minimal colouring, these wise old owls are deceptively simple.

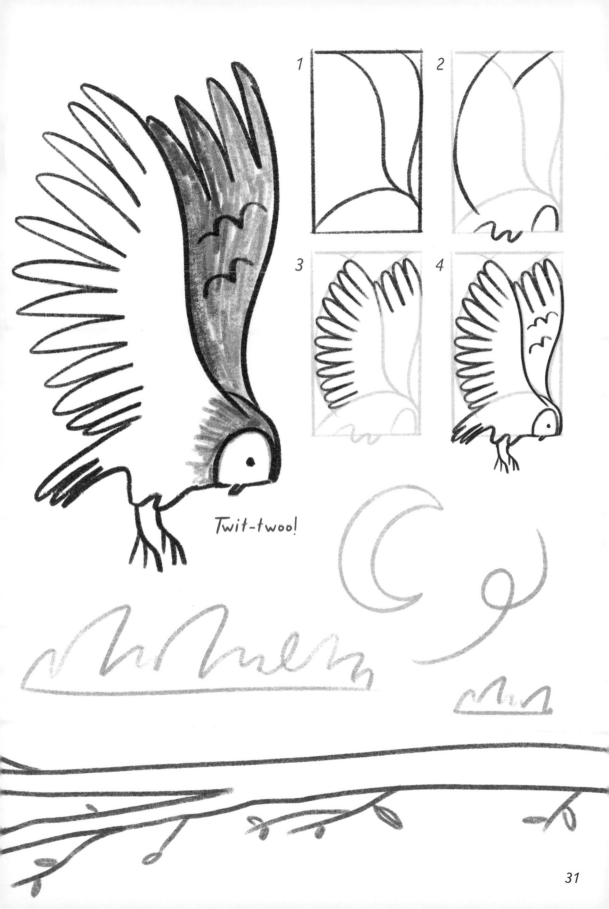

Twit-twoo!

1

2

3

4

On safari

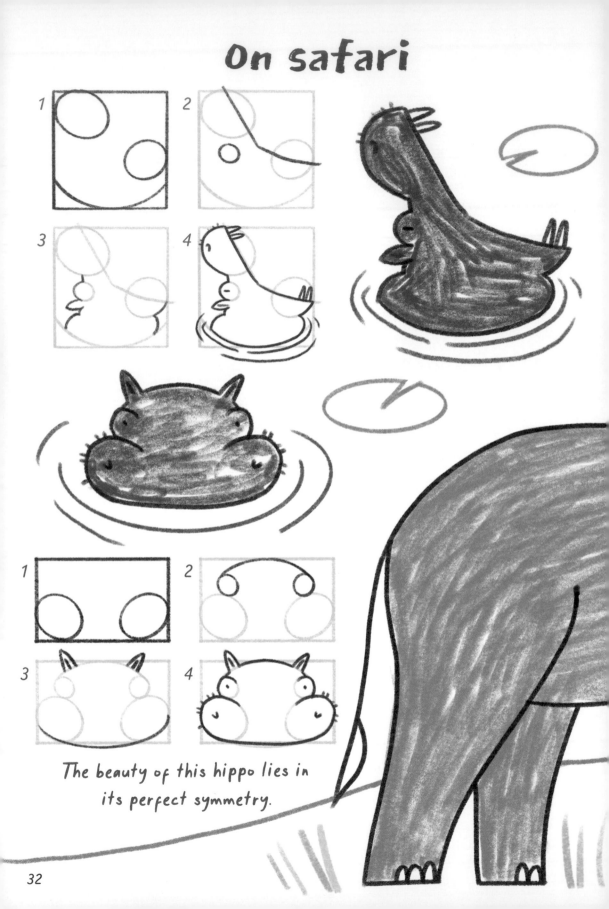

1

2

3

4

1

2

3

4

The beauty of this hippo lies in
its perfect symmetry.

Use the box to help position the circles so the
finished elephant has the correct proportions.

1

2

3

4

5

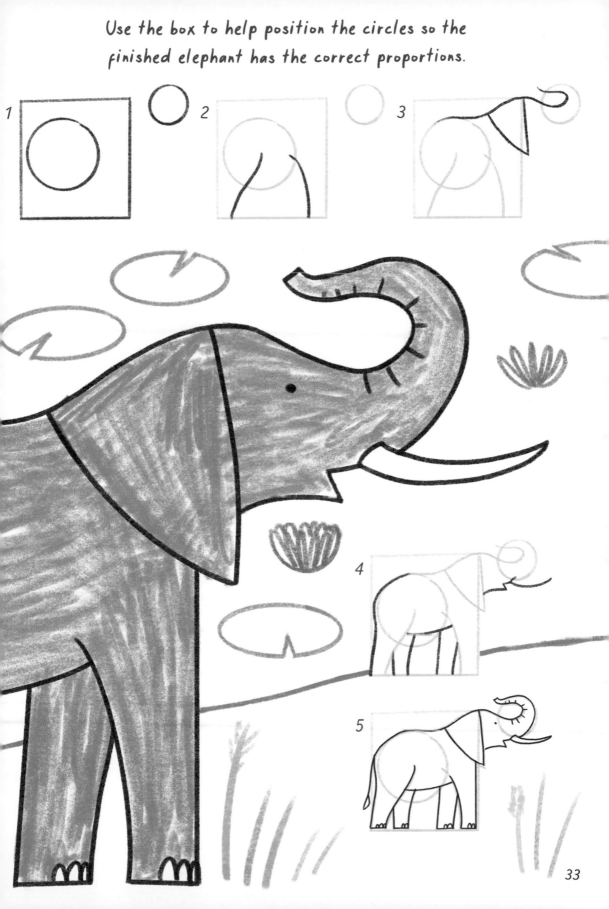

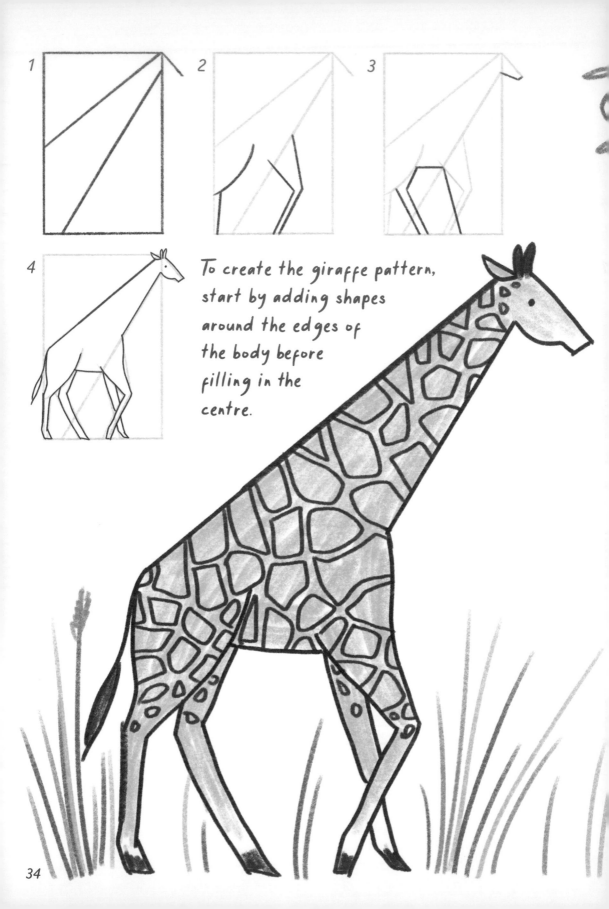

1

2

3

4

To create the giraffe pattern, start by adding shapes around the edges of the body before filling in the centre.

1

2

3

4

The zebra shares some physical similarities with a horse, but here its shorter body starts life as a single circle.

Bugs and insects

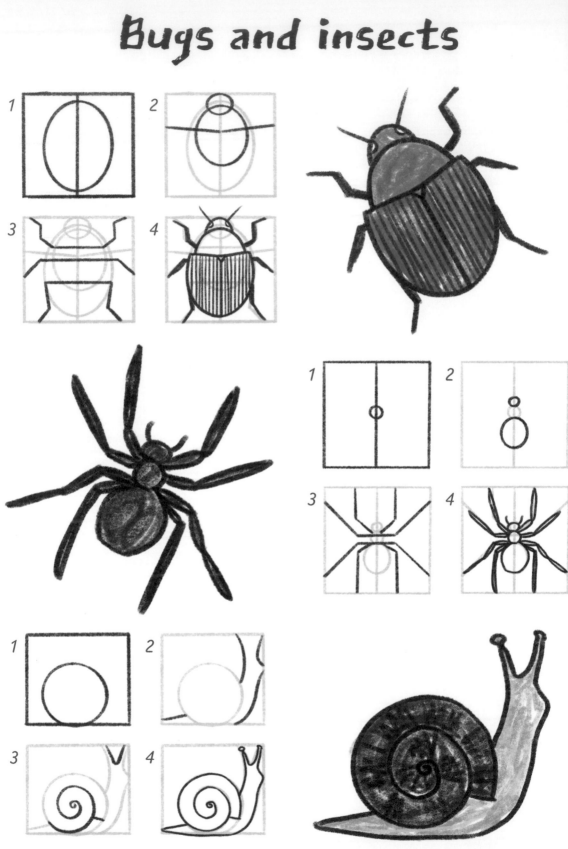

1

2

3

4

1

2

3

4

1

2

3

4

Bugs and insects come in a kaleidoscope of colours,
so you can go bright and bold with your choices.

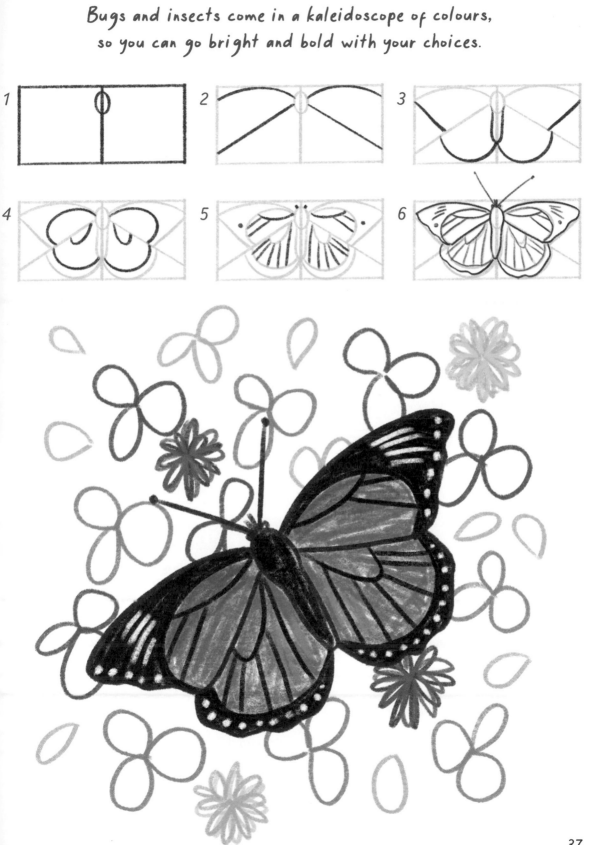

These honeybees are bound to
create a buzz in your sketchbook.

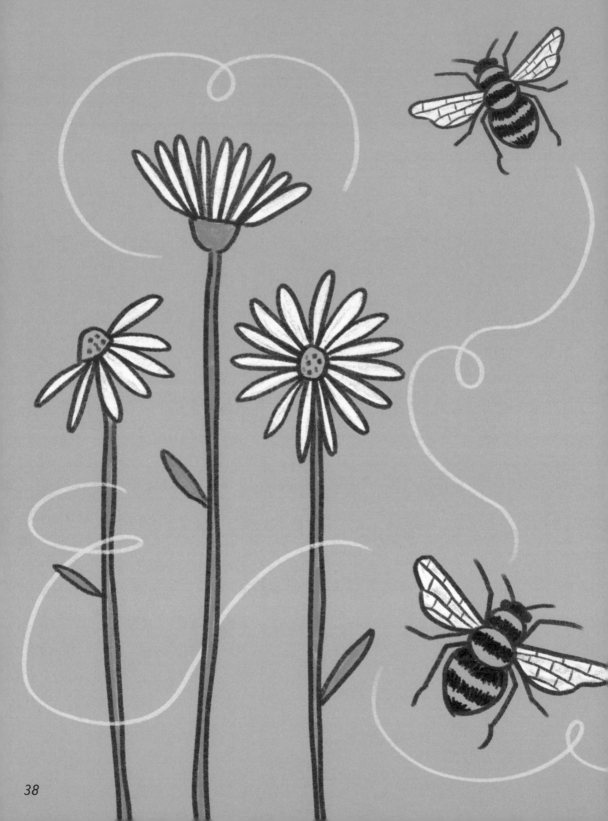

1

Start with a rectangle
and three straight
guidelines.

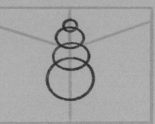

2

Add four
oval shapes.

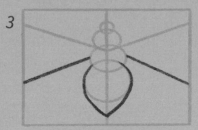

3

A teardrop shape
completes the body.
Add two more
straight lines.

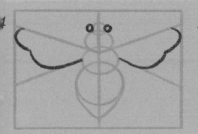

4

Complete the wings
using curved lines.
Add circles for
the eyes.

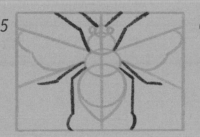

5

Add six legs and
two antennae.

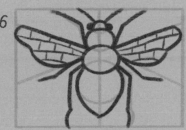

6

Trace around the
outline and add
the wing detail.

Trees and flowers

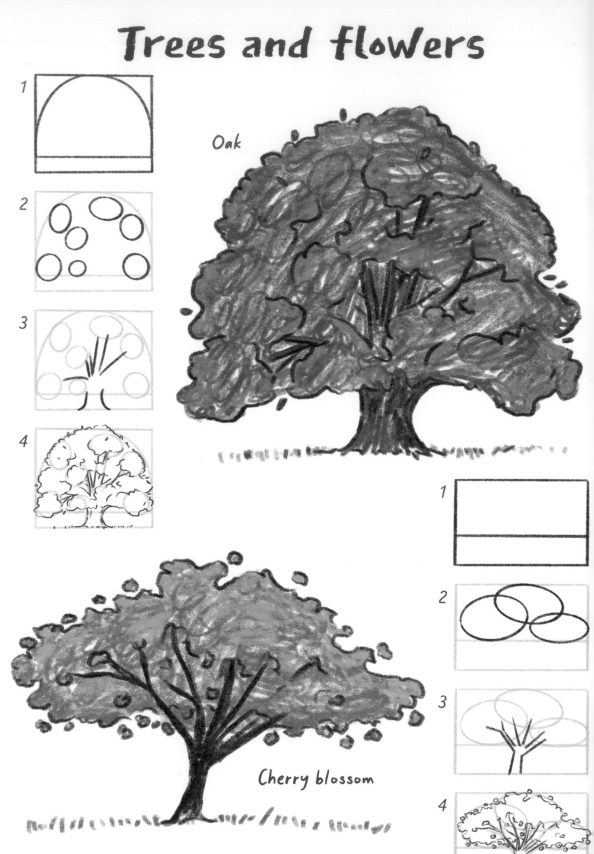

1

2

3

4

Oak

Cherry blossom

1

2

3

4

Using structural shapes beneath the branch details help to give the trees the impression of being 'full' and layered.

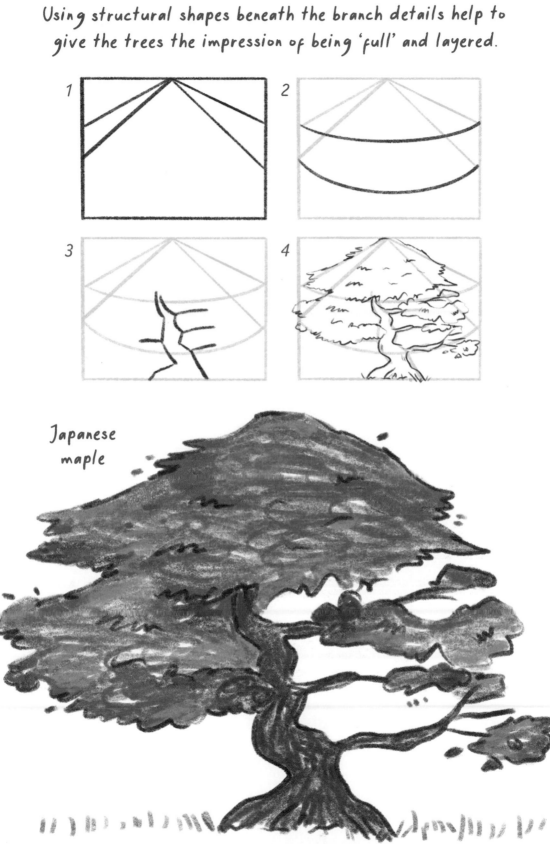

1

2

3

4

Japanese maple

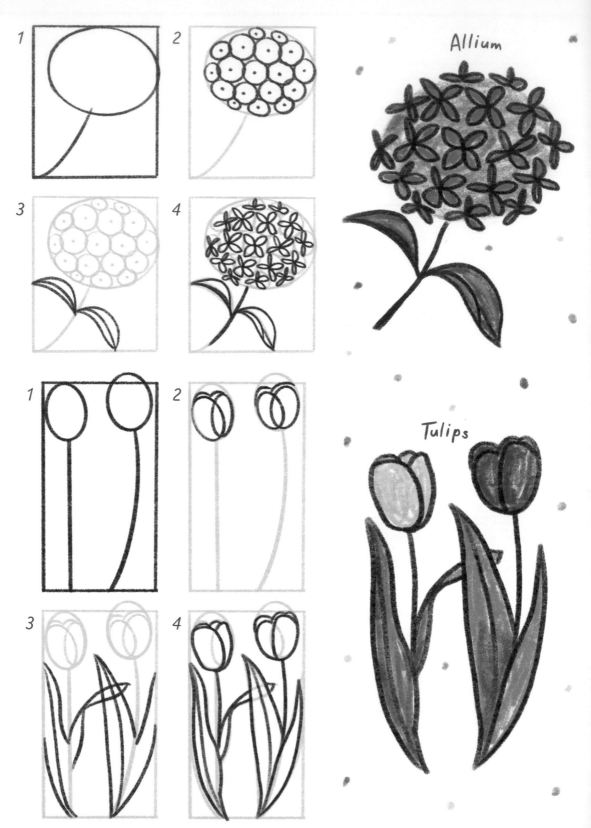

Allium

Tulips

42

1 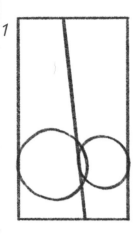 **2**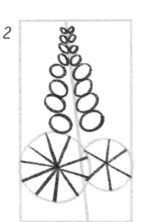

3 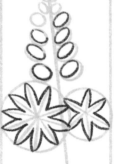 **4**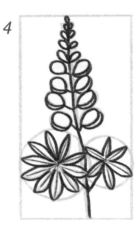

Lupin

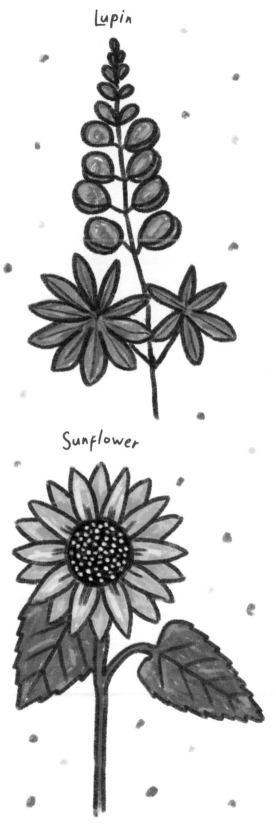

1 **2**

3 **4**

Sunflower

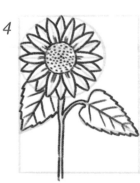

At the pond

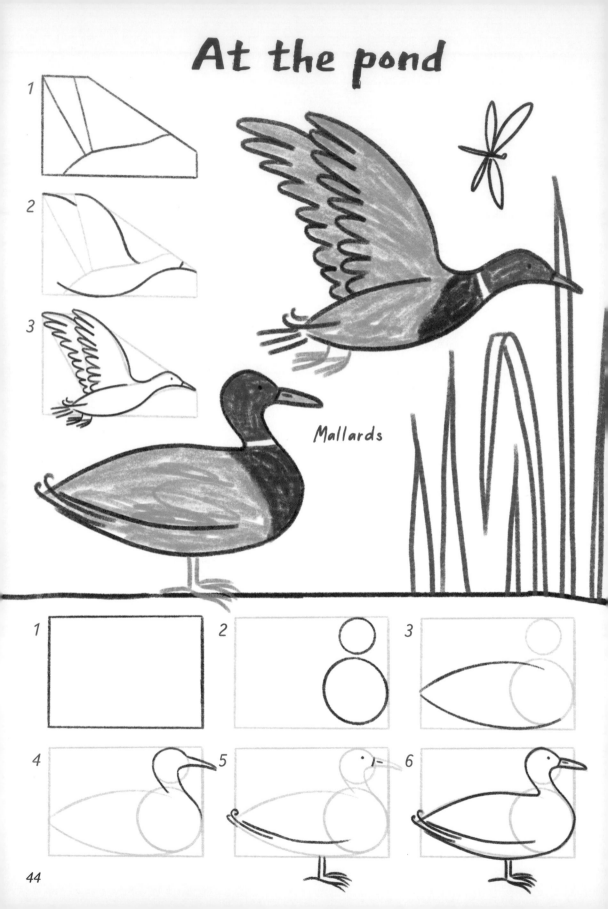

1

2

3

Mallards

1

2

3

4

5

6

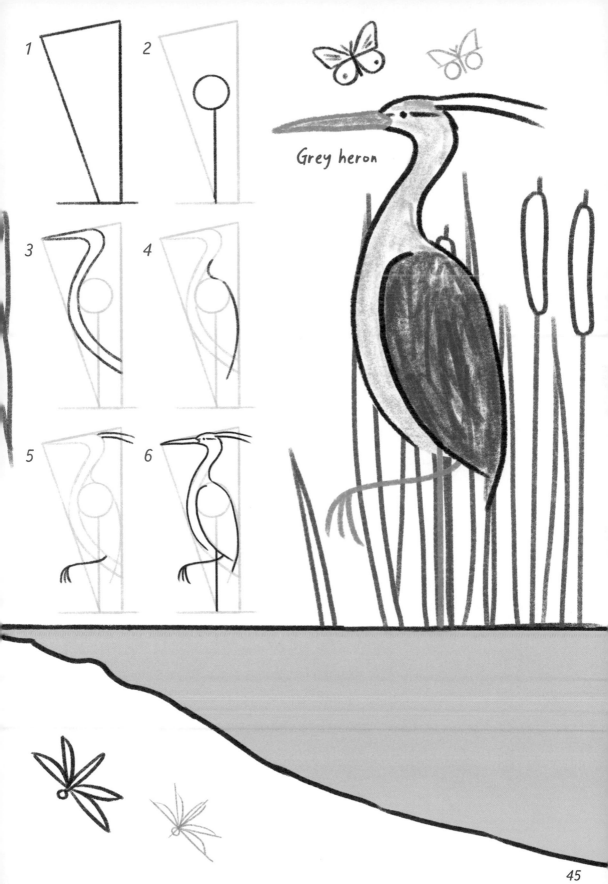

1

2

3

4

5

6

Grey heron

Drawing a straight-line grid to help with curved lines seems counter-intuitive, but makes it easier to keep the curves in the right places.

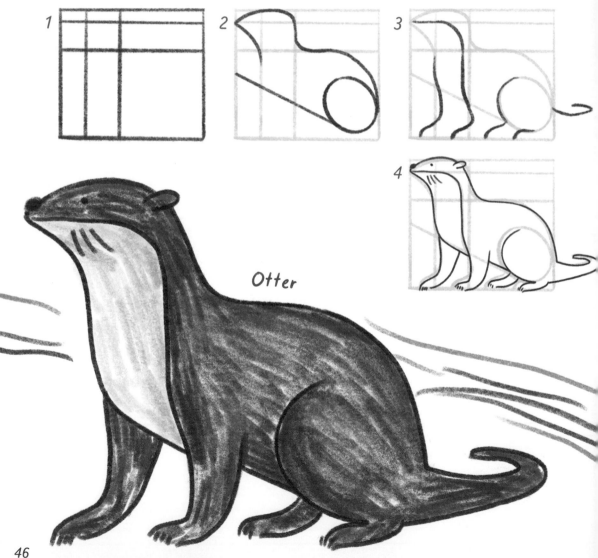

Otter

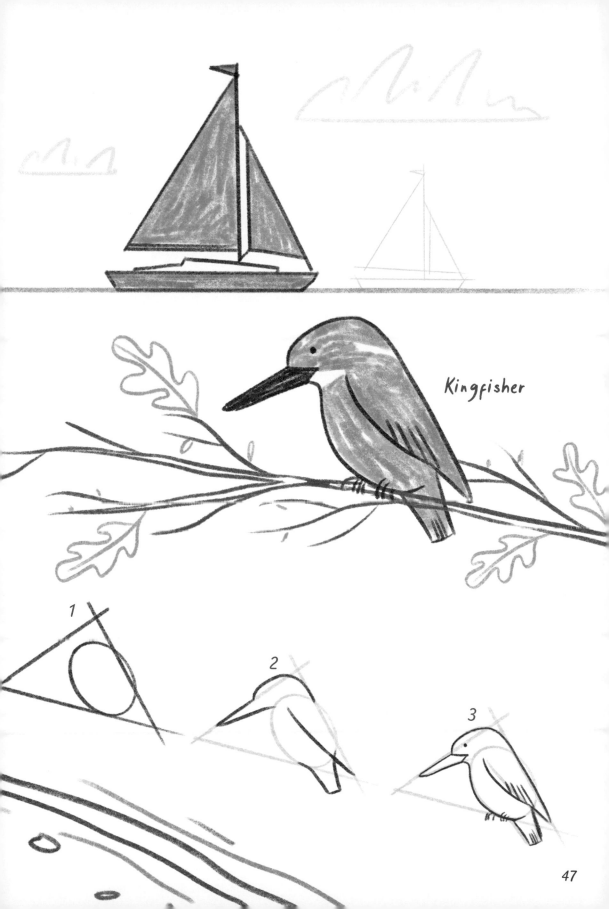

Kingfisher

1

2

3

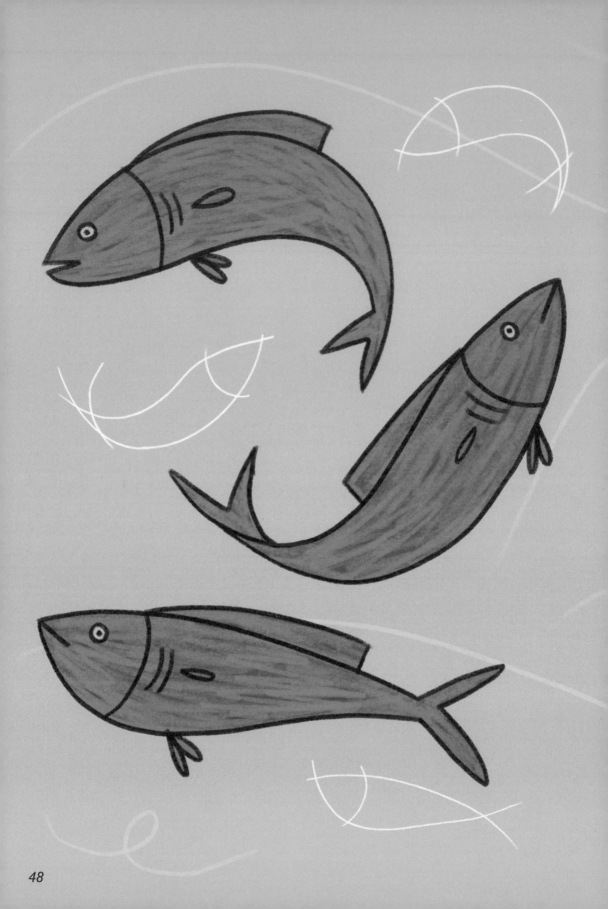

Flowing lines give the fish a sense of movement.

On the farm

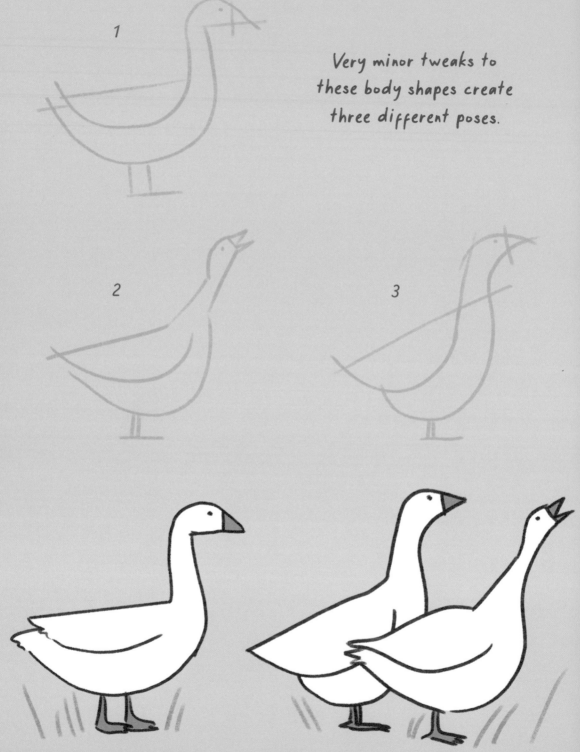

1

Very minor tweaks to these body shapes create three different poses.

2

3

Four circles give structure
to the horse's body.

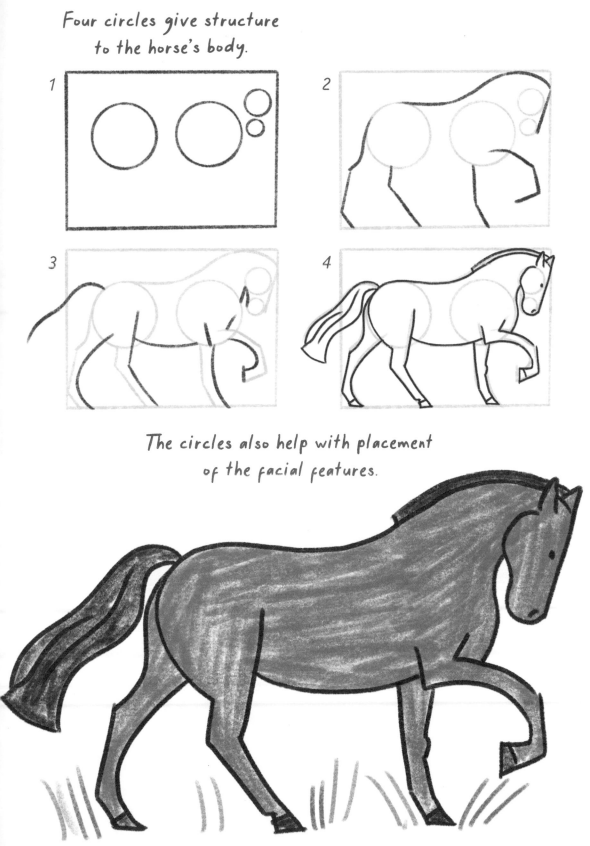

The circles also help with placement
of the facial features.

A pair of rabbits

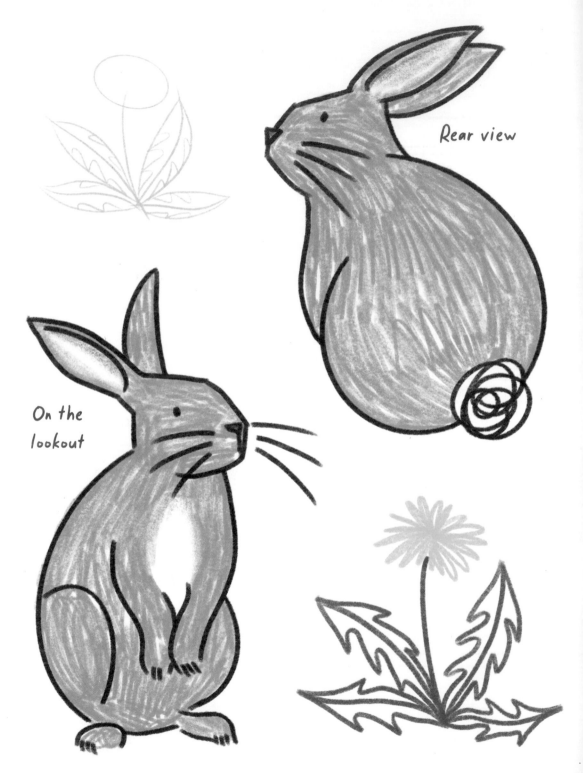

Rear view

On the lookout

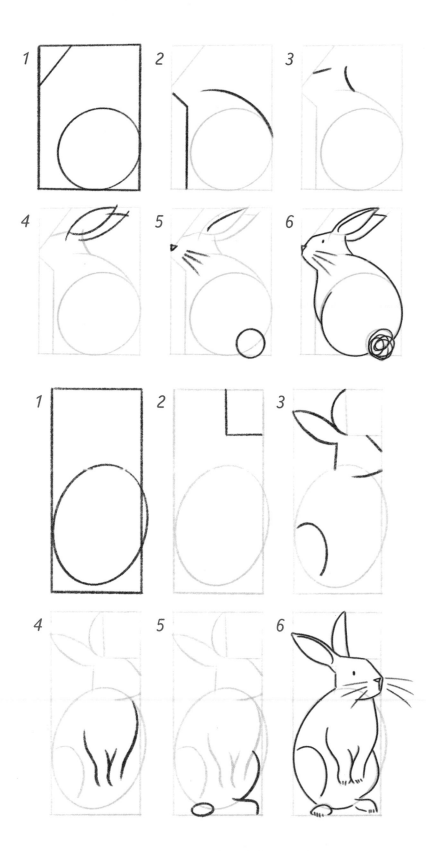

Arctic explorers

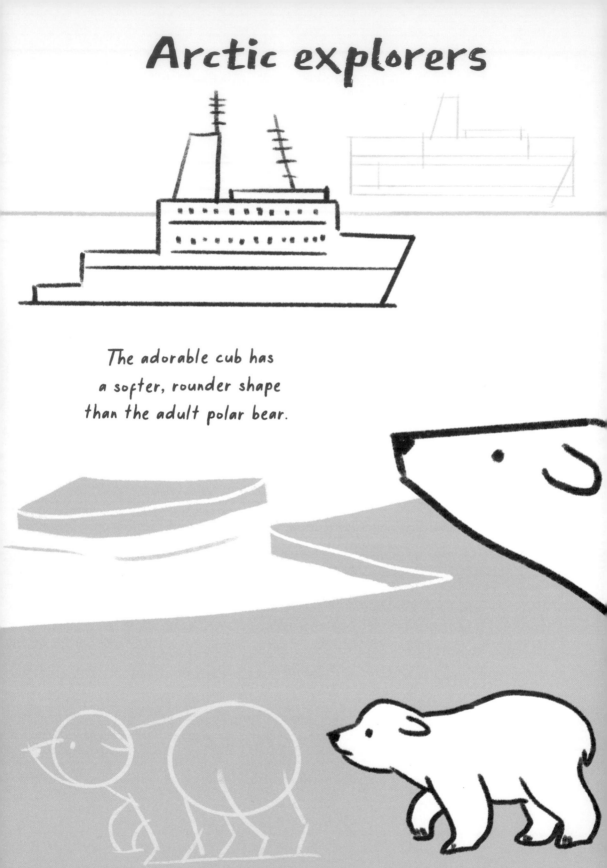

The adorable cub has
a softer, rounder shape
than the adult polar bear.

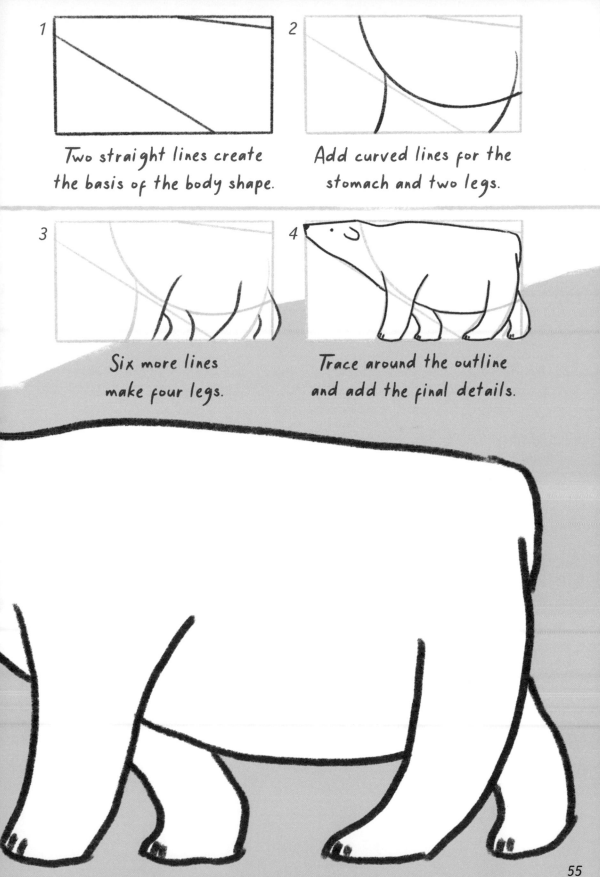

1 Two straight lines create the basis of the body shape.

2 Add curved lines for the stomach and two legs.

3 Six more lines make four legs.

4 Trace around the outline and add the final details.

In the outback

The angle of the limbs helps to create the illusion that the kangaroo is in motion.

Fast forward!

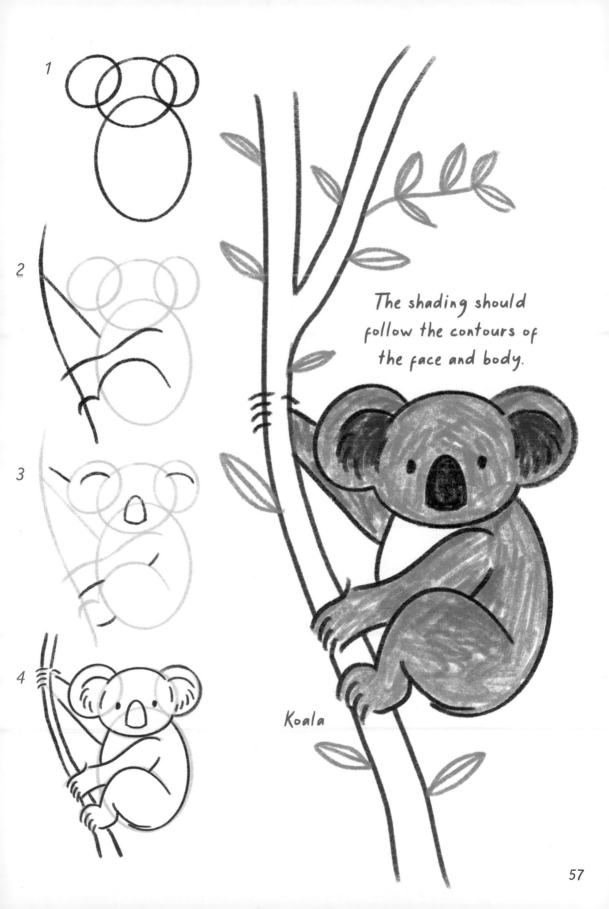

1

2

3

4

The shading should follow the contours of the face and body.

Koala

Buildings

1

2

3

Eiffel Tower

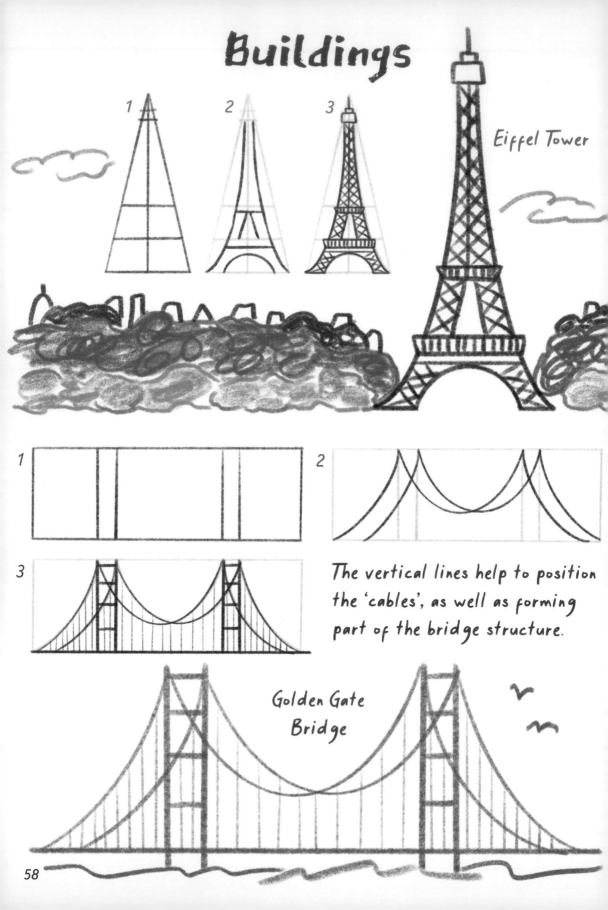

1

2

The vertical lines help to position the 'cables', as well as forming part of the bridge structure.

3

Golden Gate
Bridge

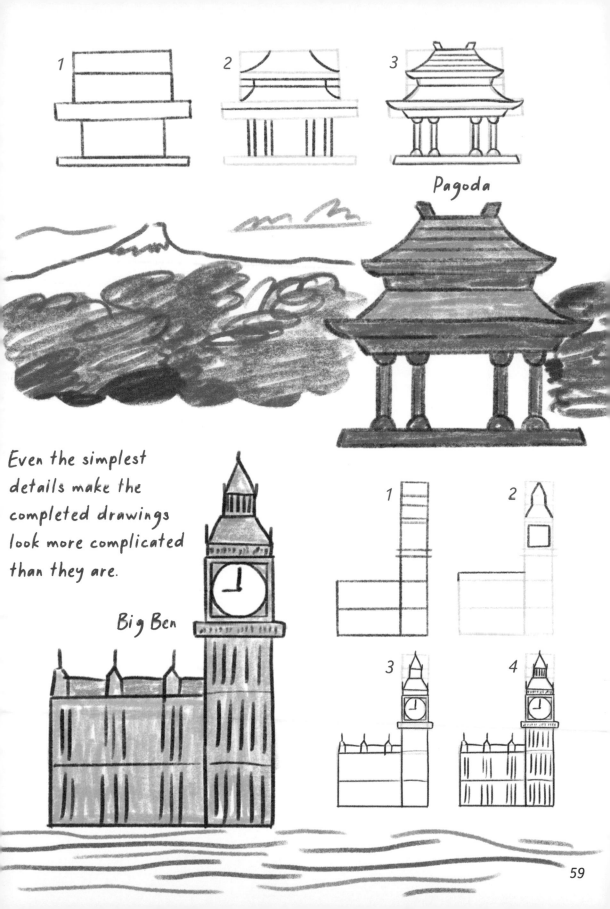

1 2 3

Pagoda

Even the simplest details make the completed drawings look more complicated than they are.

Big Ben

1 2

3 4

It's all about the large circular base shape,
which sets the position of the windmill blades.

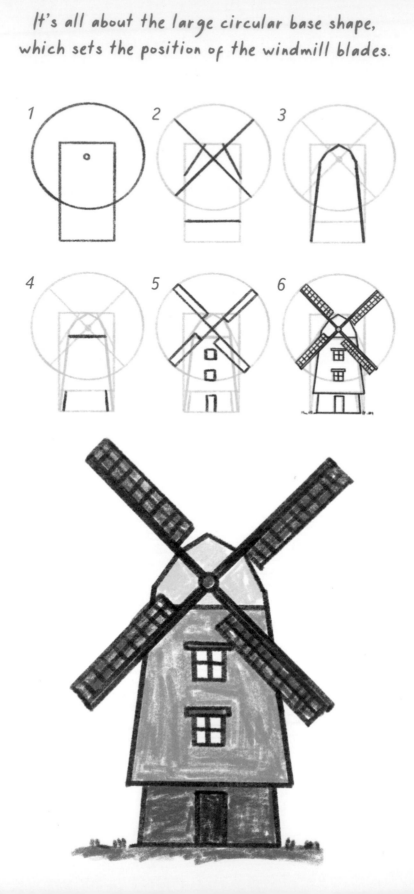

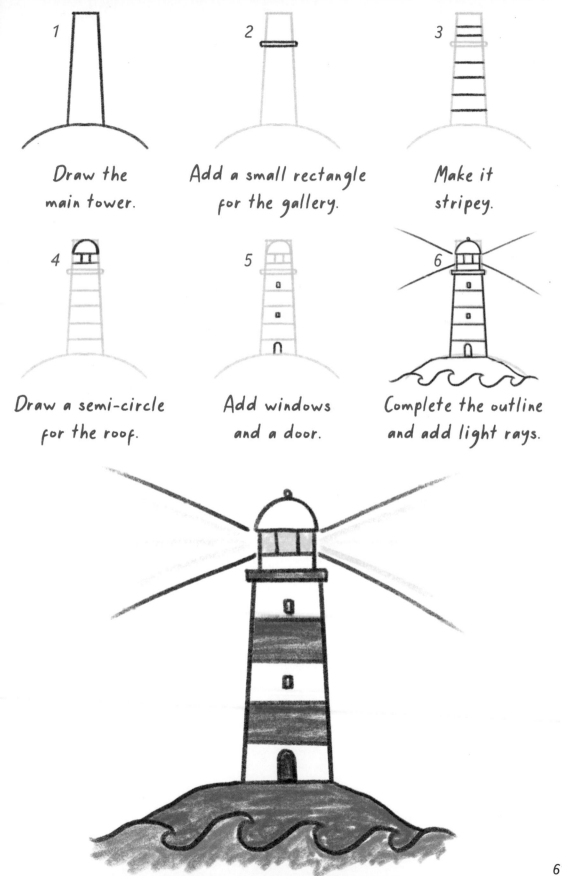

1 Draw the
main tower.

2 Add a small rectangle
for the gallery.

3 Make it
stripey.

4 Draw a semi-circle
for the roof.

5 Add windows
and a door.

6 Complete the outline
and add light rays.

Up and away

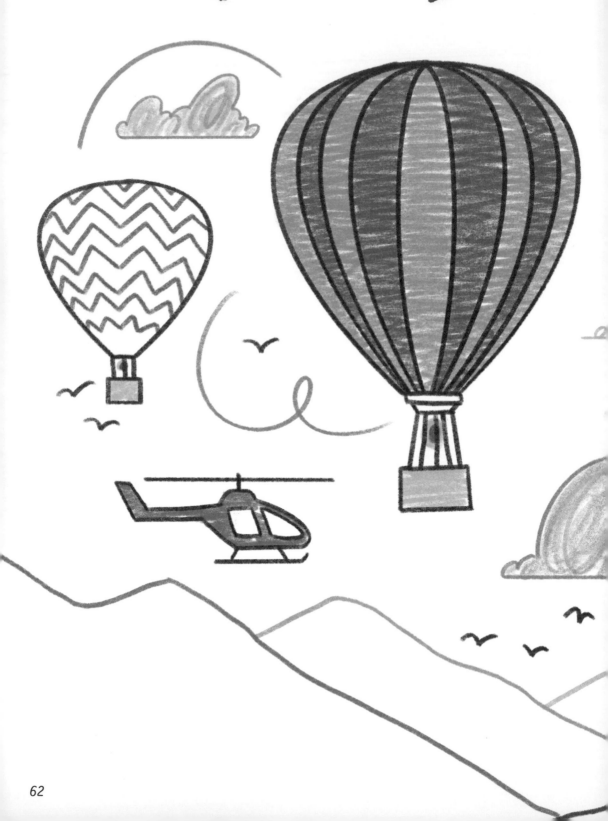

Start with a large oval.

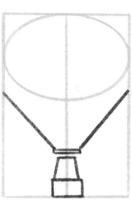

2

Add two straight lines for the lower balloon and a square basket.

3

Join the two lines with a loop using the initial oval shape as a guide.

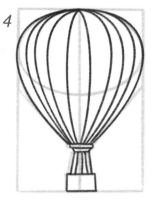

4

Add stripes to the balloon and ropes to the basket.

1

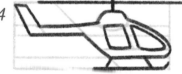

2

3

4

Things that go

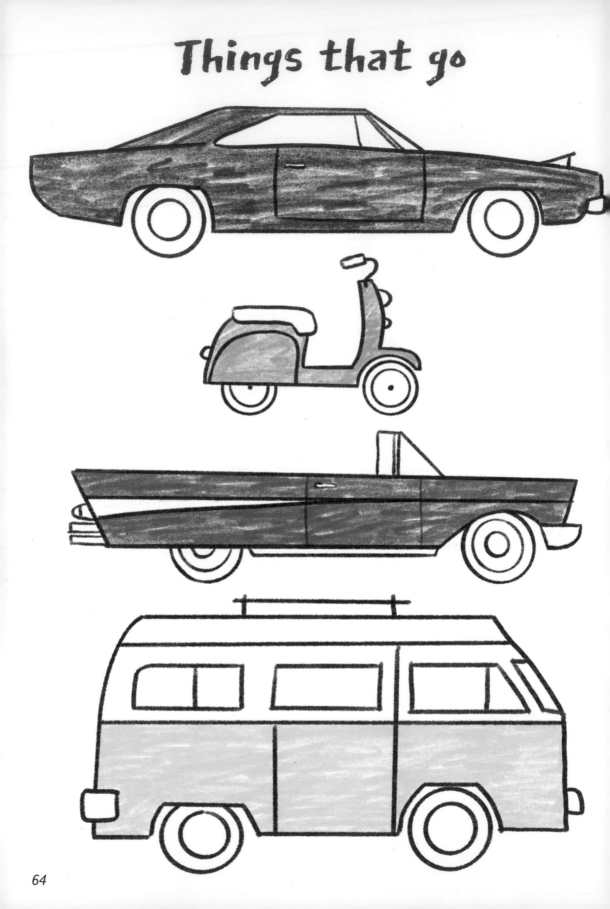

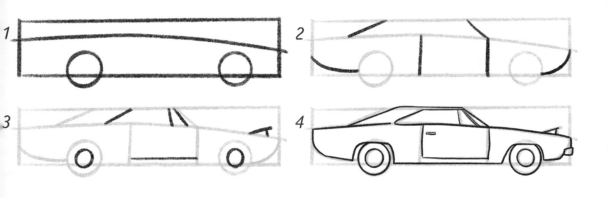

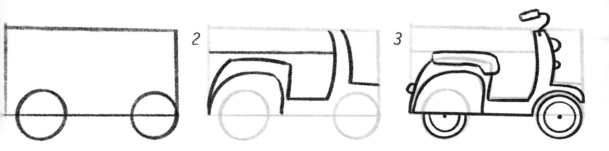

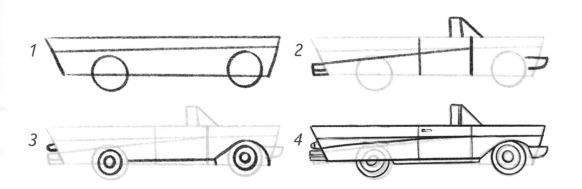

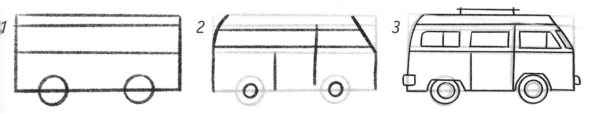

House plants

2

3

4

5

The three circles provide a positional guide for the heart-shaped leaves and the lobes.

Monstera

66

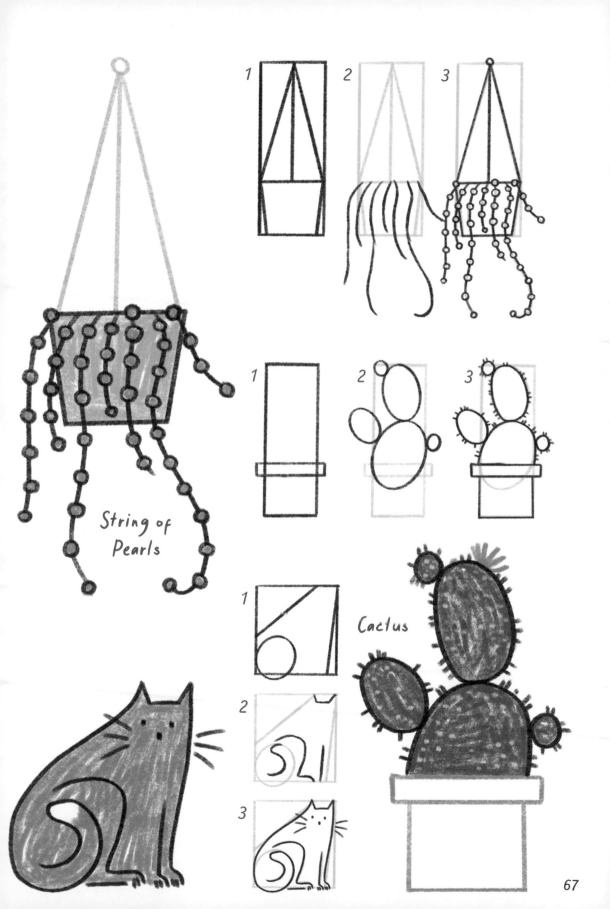

String of
Pearls

Cactus

1
2
3

67

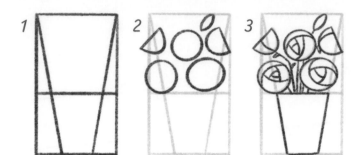

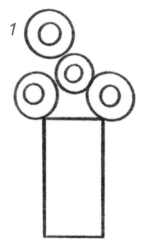
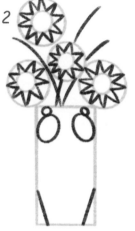
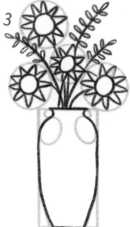

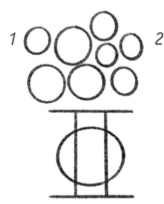
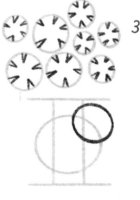
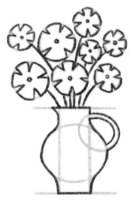

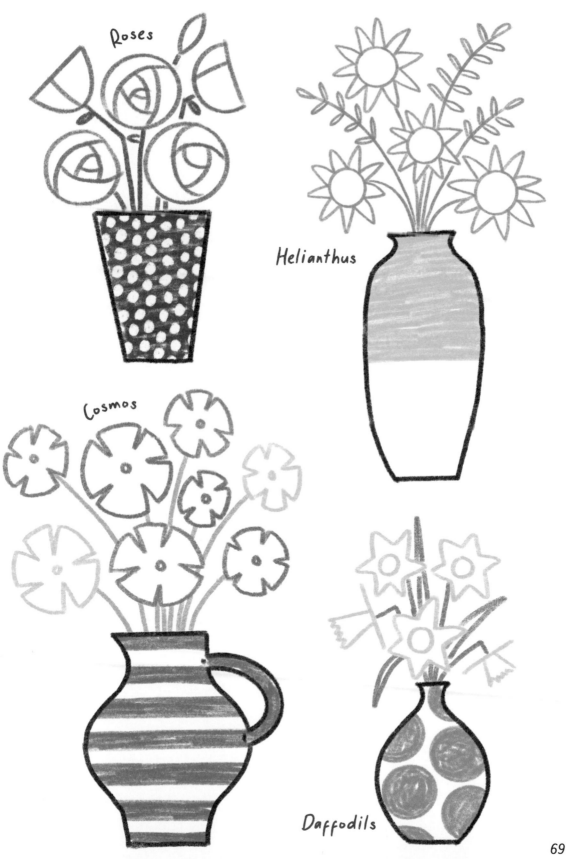

Roses

Helianthus

Cosmos

Daffodils

69

Design classics

The design maxim of 'simple is best' is borne out by these iconic mid-century designs.

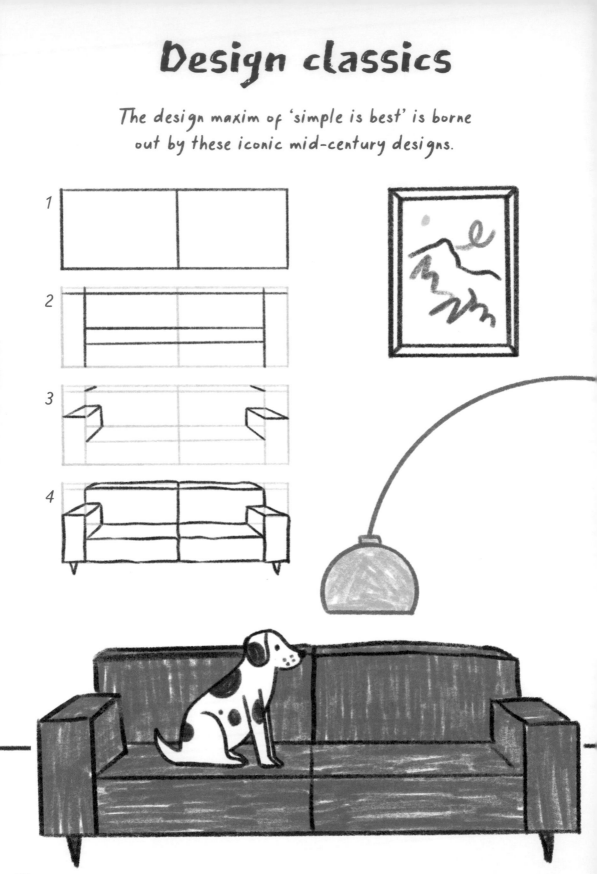

1

2

3

4

Start with a circle to create the dramatic curve of this stylish arc lamp.

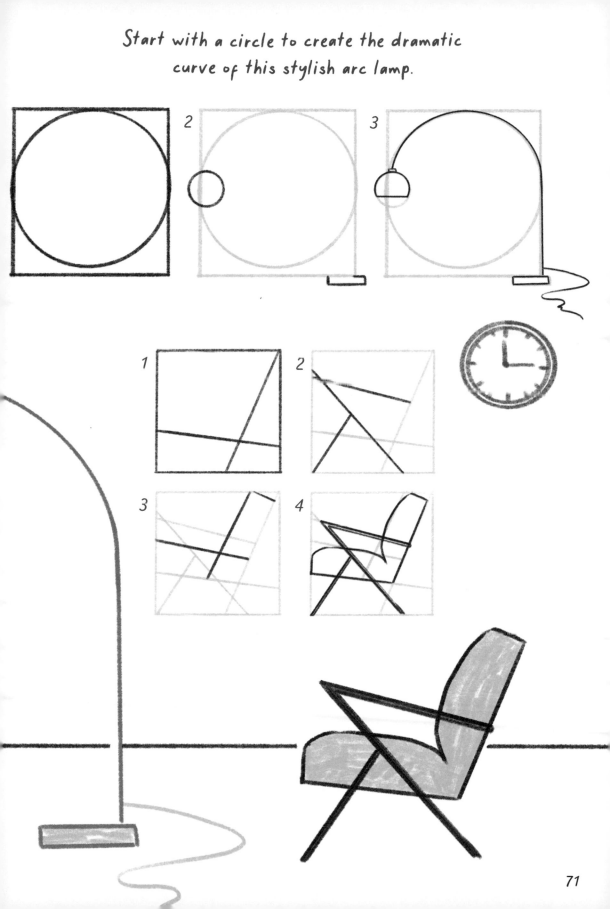

2

3

1

2

3

4

71

Musical instruments

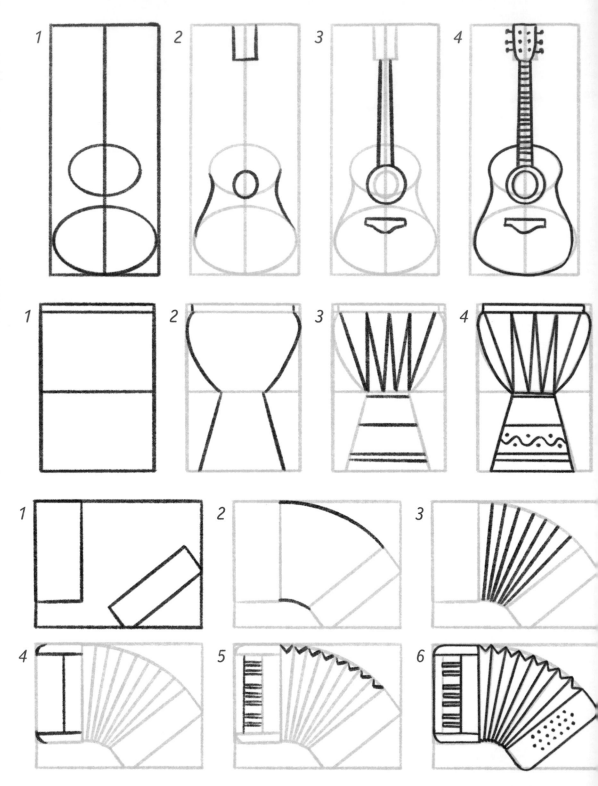

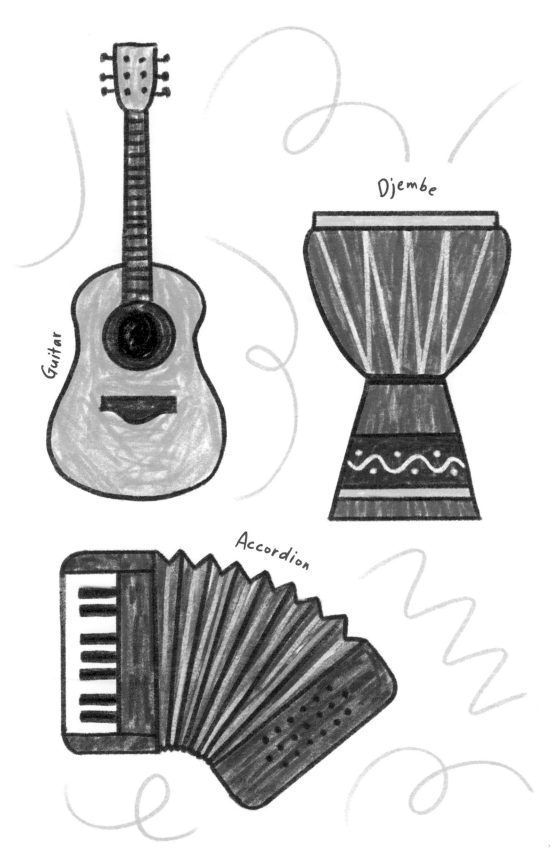

Guitar

Djembe

Accordion

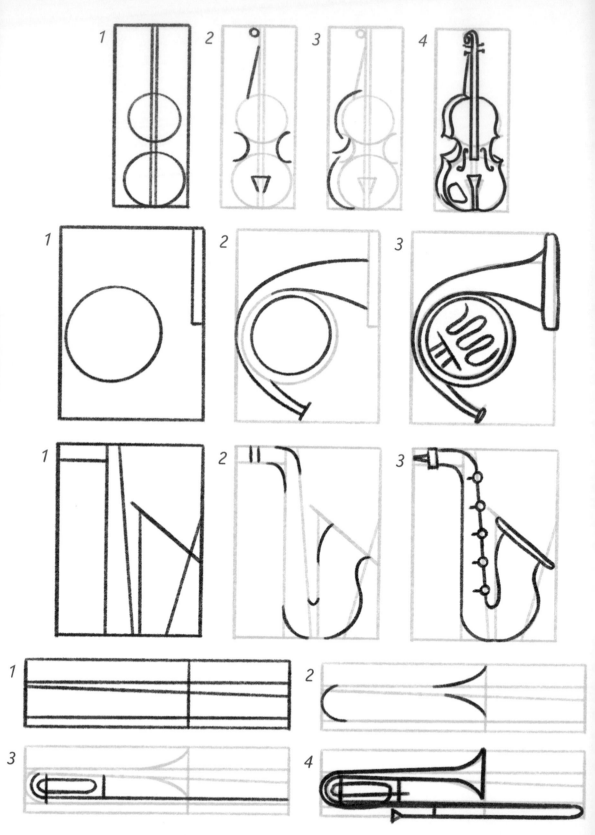

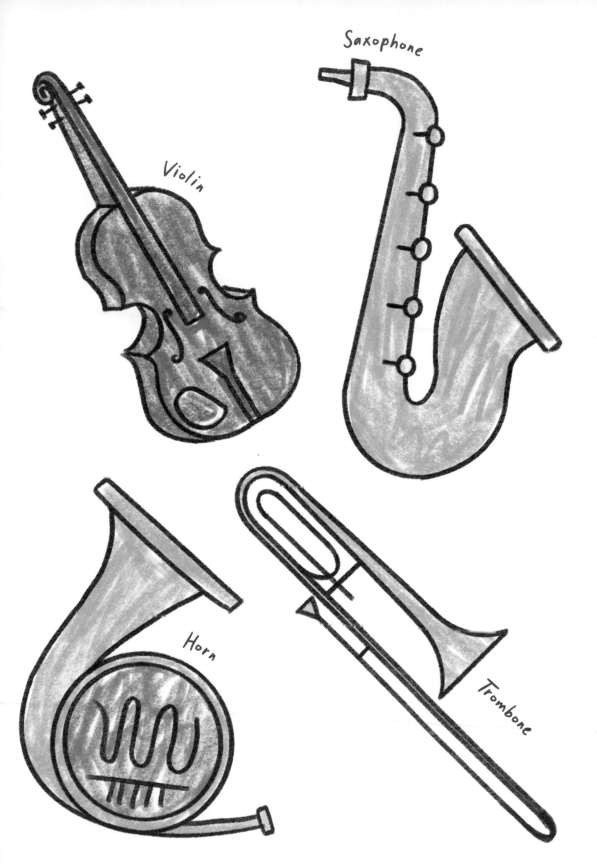

Saxophone

Violin

Horn

Trombone

Things to eat

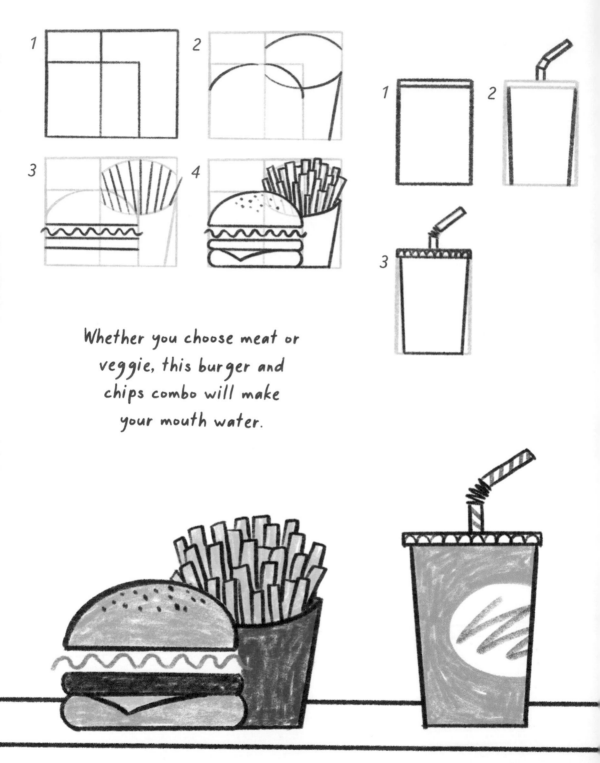

Whether you choose meat or veggie, this burger and chips combo will make your mouth water.

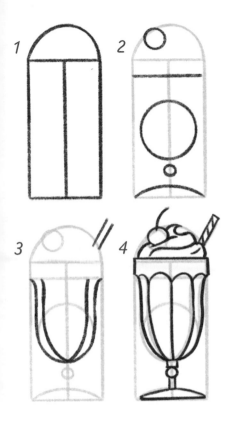

1 2 3 4

Your favourite foods might
become your favourite
things to draw!

1 2

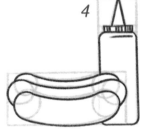

3 4

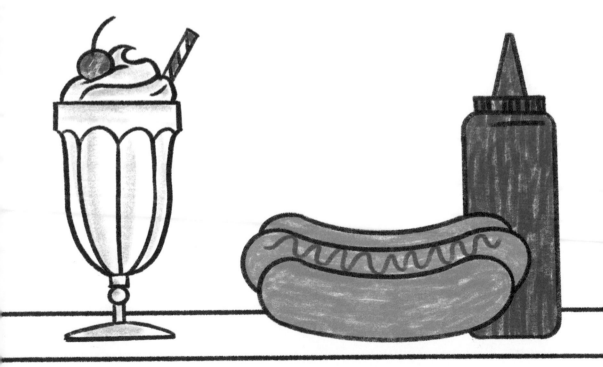

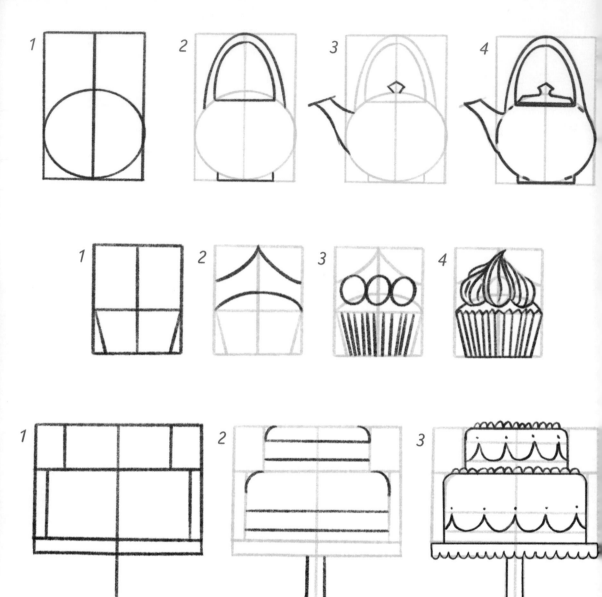

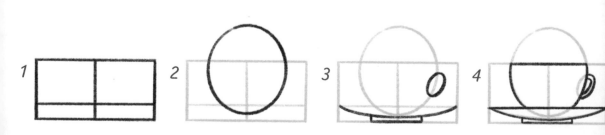

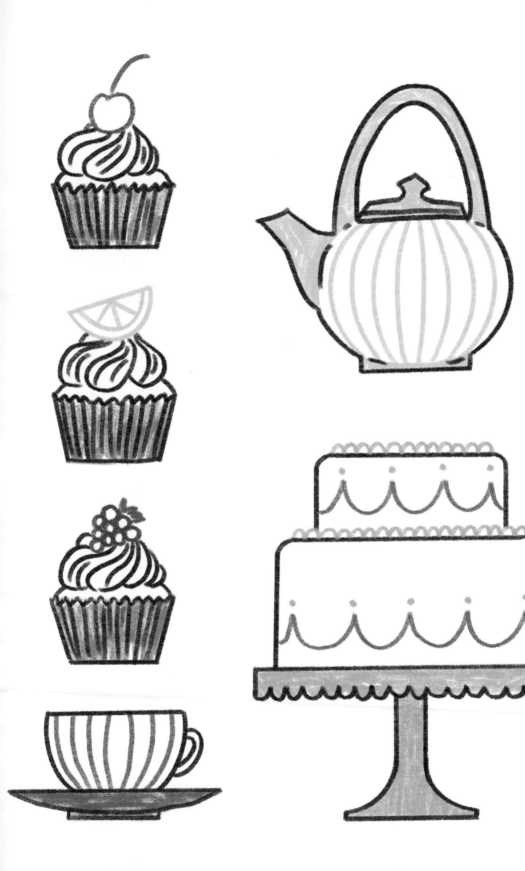

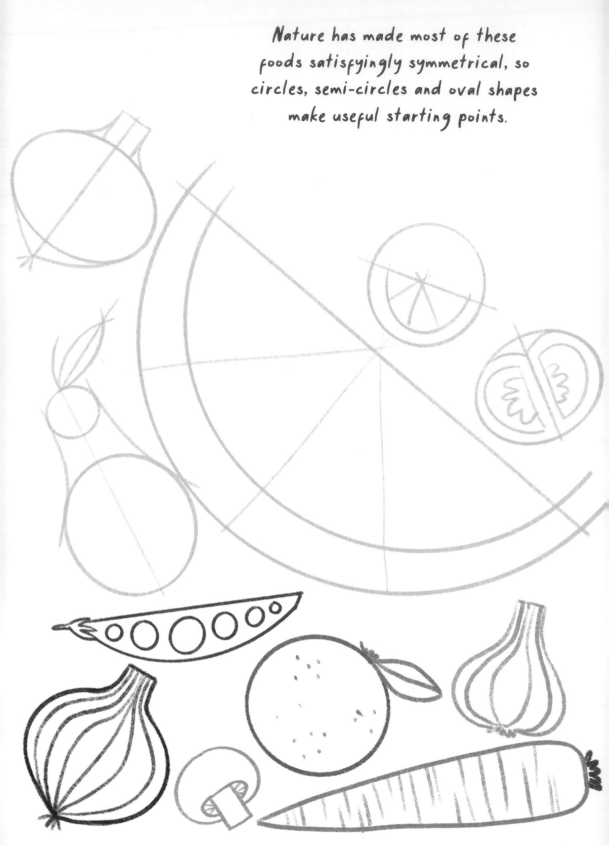

Nature has made most of these foods satisfyingly symmetrical, so circles, semi-circles and oval shapes make useful starting points.

Get your five-a-day
by drawing delicious
fruit and veg.

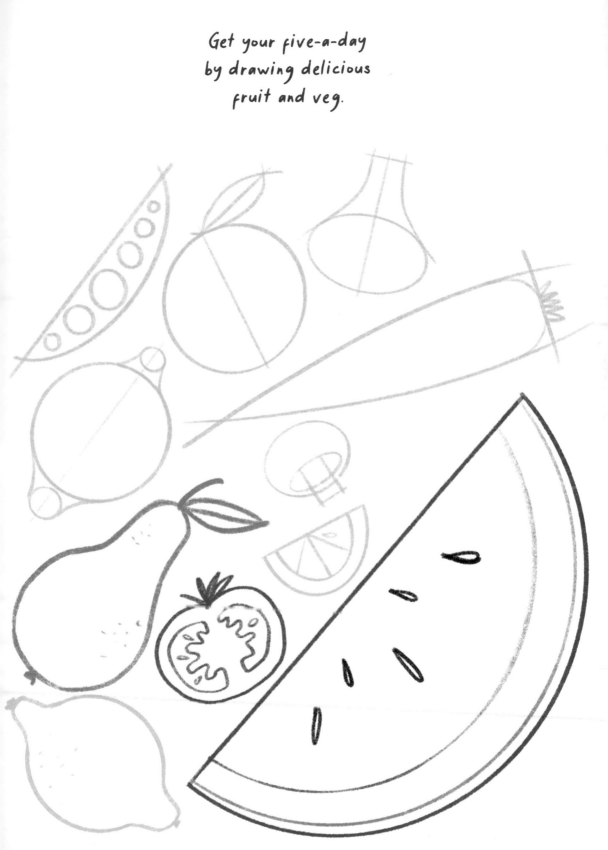

In the kitchen

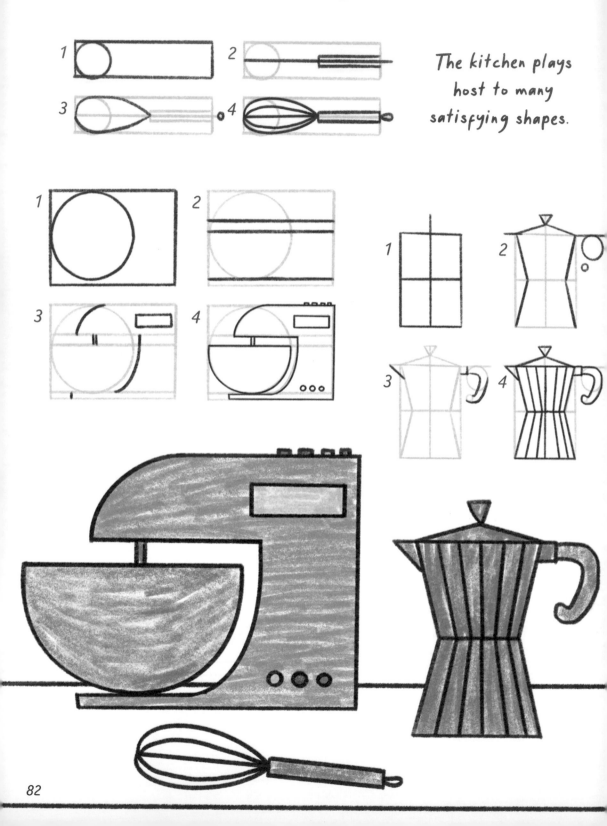

The kitchen plays host to many satisfying shapes.

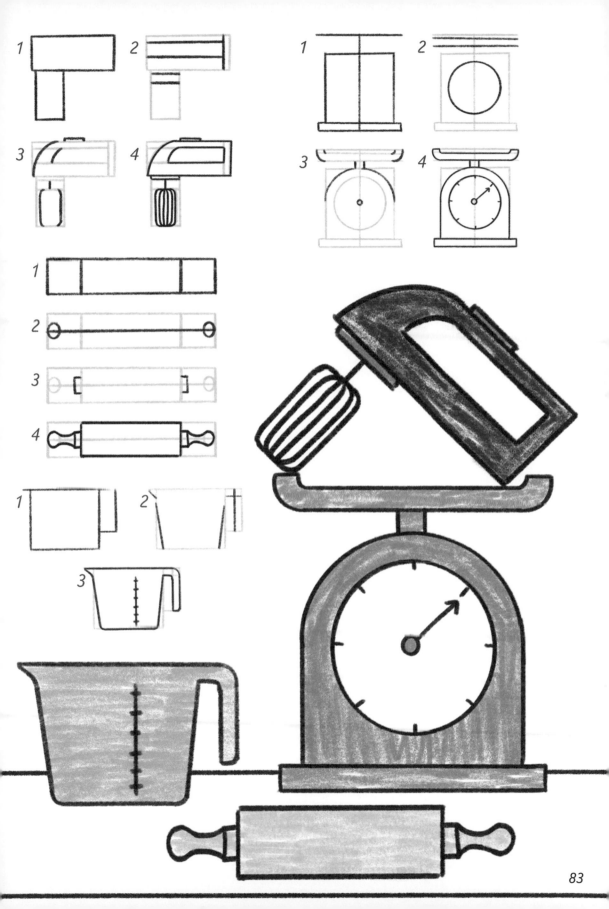

On the move

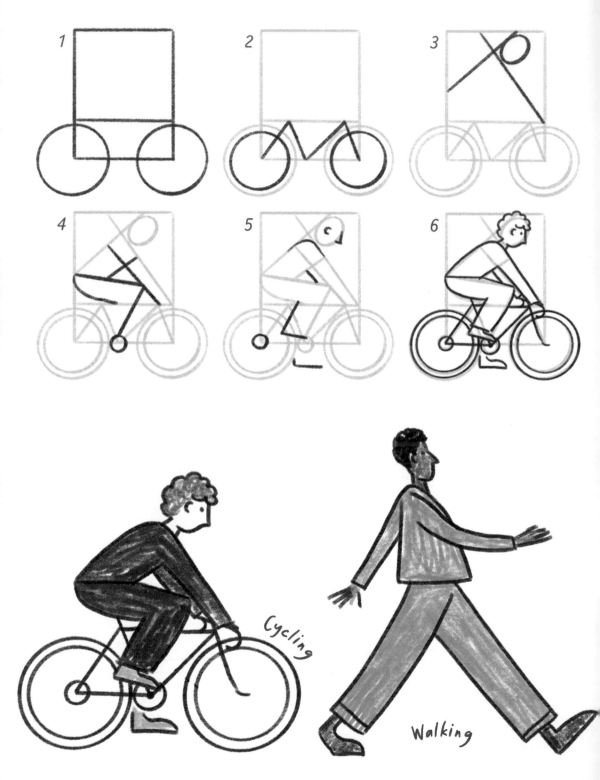

1

2

3

4

5

6

Cycling

Walking

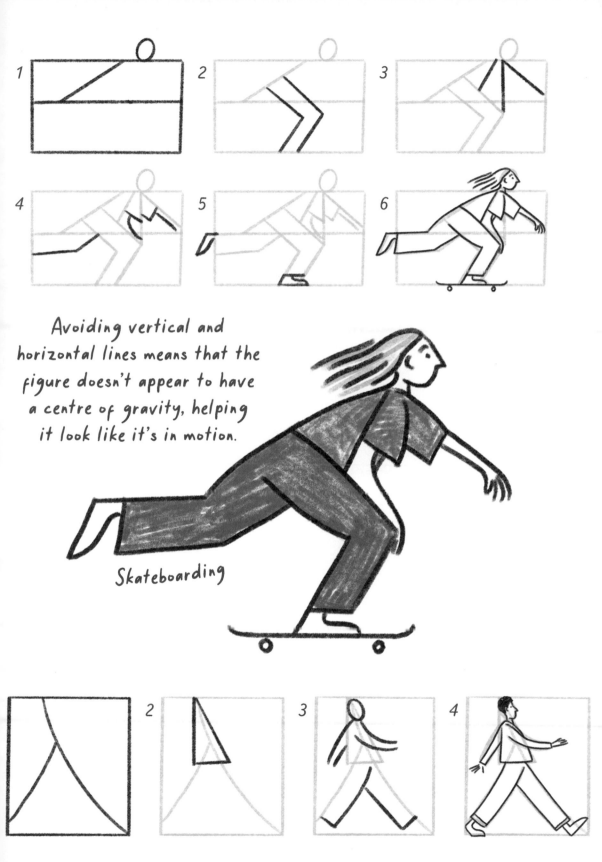

Avoiding vertical and horizontal lines means that the figure doesn't appear to have a centre of gravity, helping it look like it's in motion.

Skateboarding

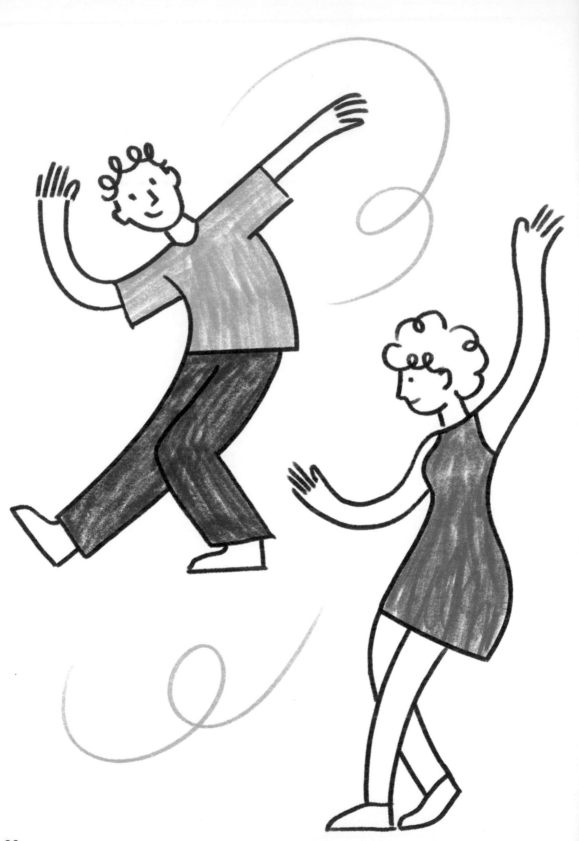

Try to use soft strokes,
as heavy lines will
make the figures
appear more static.

The more relaxed
your hand, the better
the result will be,
particularly when it
comes to flowing
lines like these.

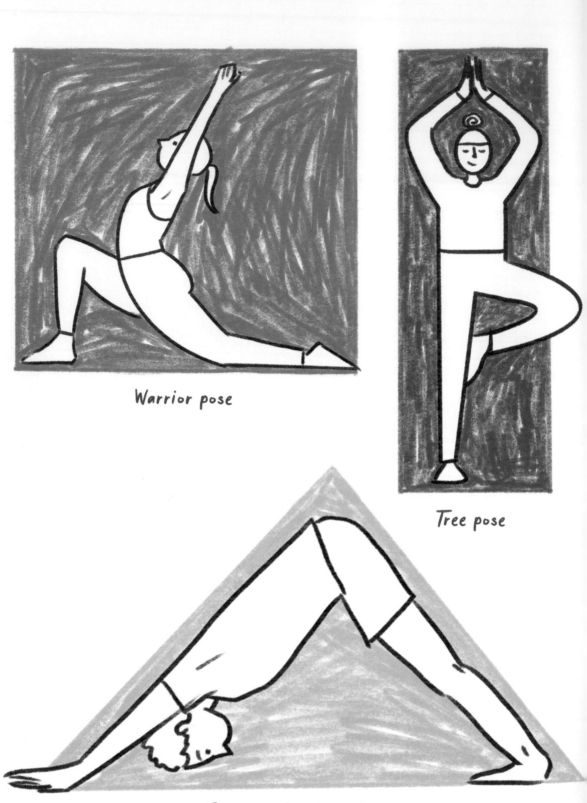

Warrior pose

Tree pose

Downward-facing dog

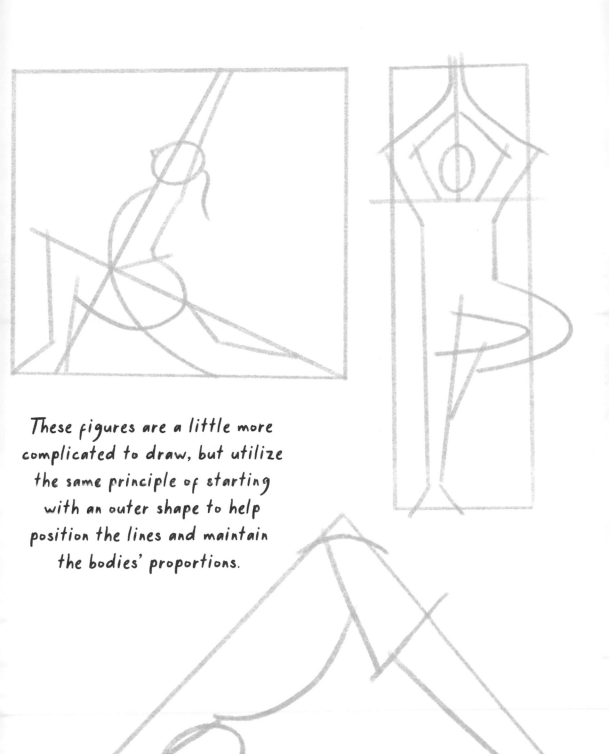

These figures are a little more complicated to draw, but utilize the same principle of starting with an outer shape to help position the lines and maintain the bodies' proportions.

Still life

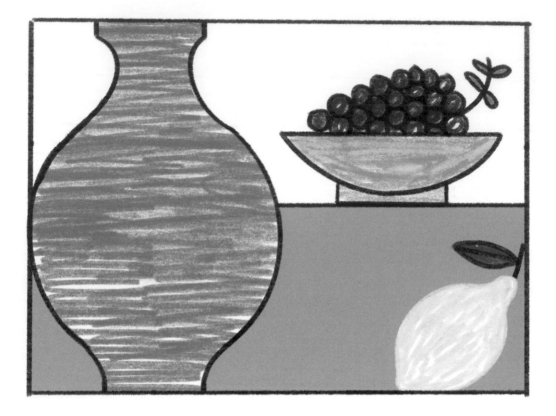

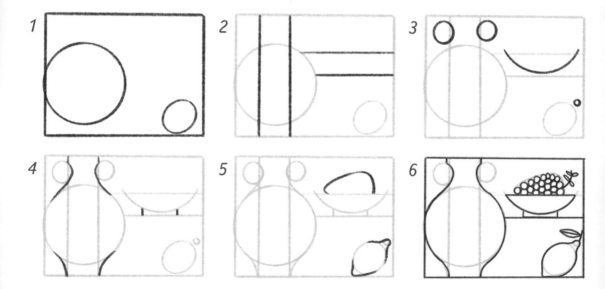

Still-life drawing has the reputation
of being tricky to master, but these
compositions keep things simple.

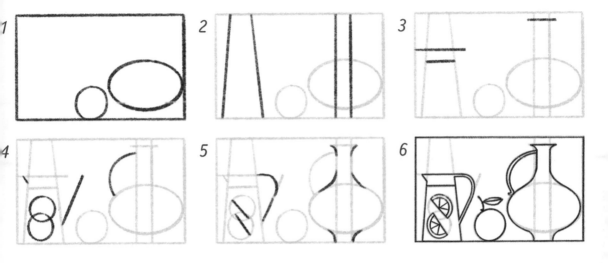

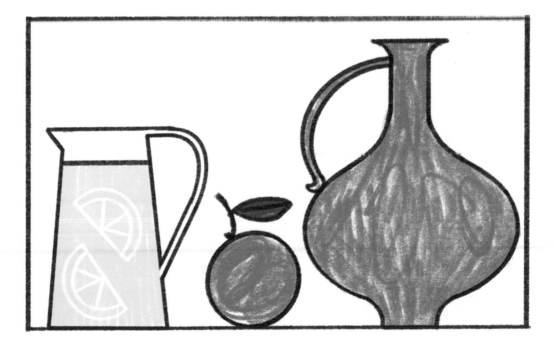

Picture perfect

Postcard-style scenes

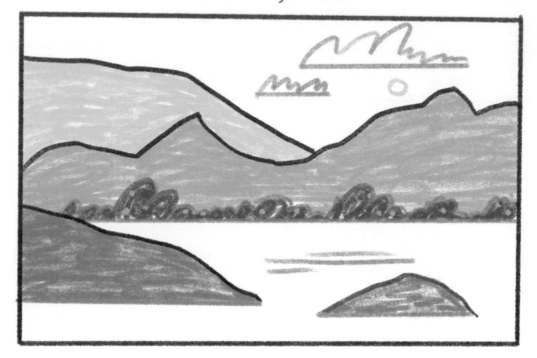

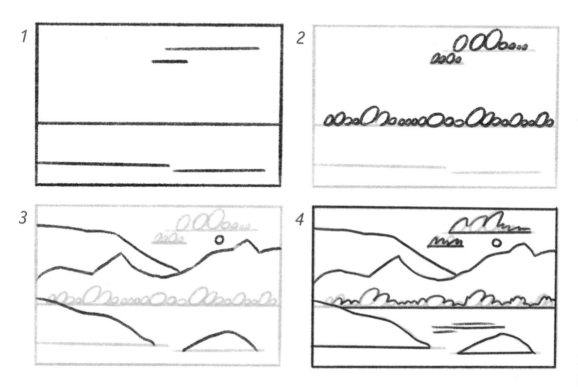

1

2

3

4

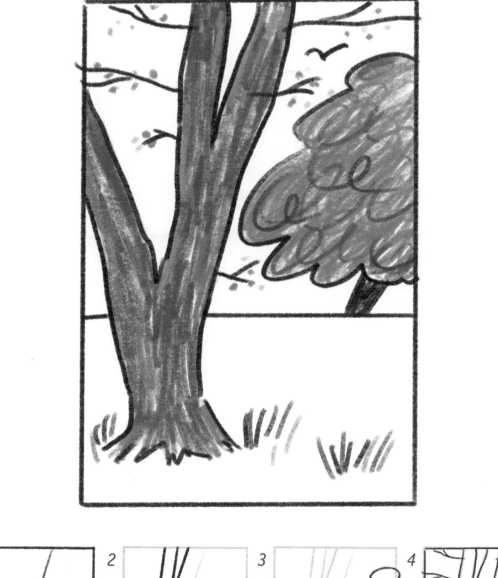

2

3

4

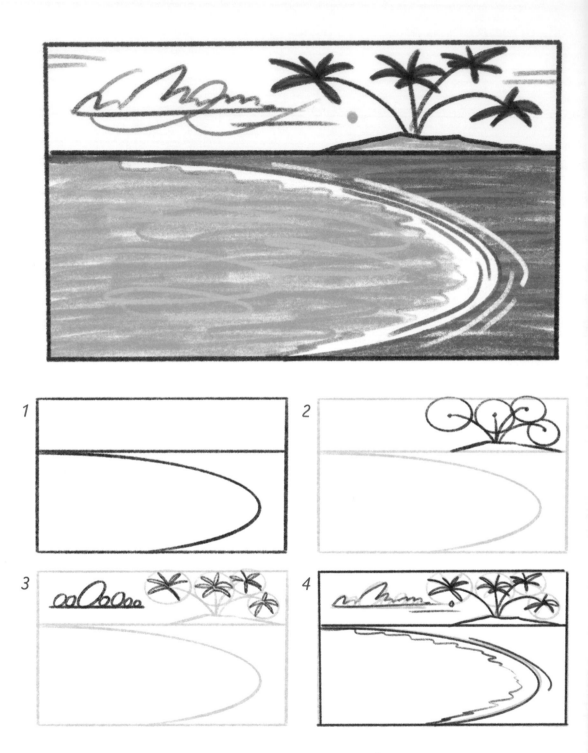

Wish you were here!

This composition uses straight lines
to give an impressive sense of
perspective to a streetscape.

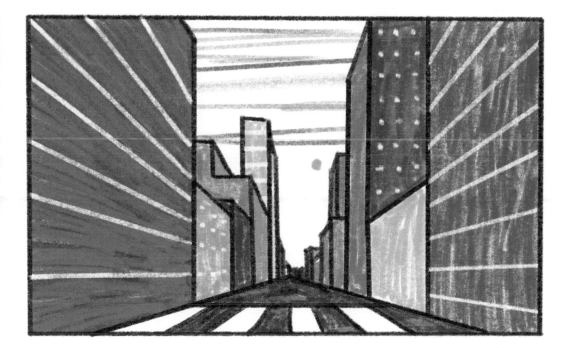

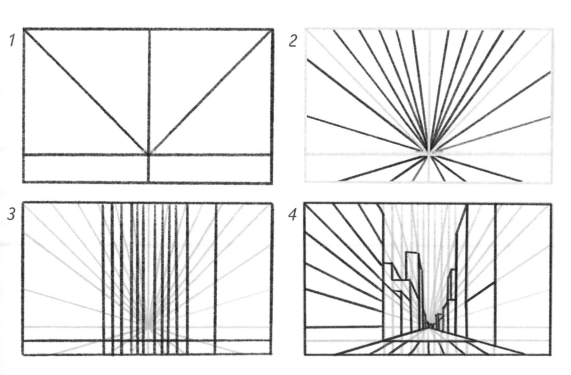

Index

accordion 72–73
allium 42
badger 26–27
bee 38–39
beetle 36
Big Ben 59
blackbird 28
boat 47, 54
burger 76–77
butterfly 37, 45
cactus 67
cake 78–79
campervan 64–65
car 64–65
carrot 80–81
cat 19, 67
chair 71
cherry blossom tree 40
chicken 6–7
cockatoo 23
coffee pot 82
cosmos 68–69
crab 13
daffodil 68–69
dandelion 53
djembe 72–73
dog 16–18
dragonfly 45
drink 76
duck 50
Eiffel Tower 58
electric whisk 83
elephant 32–33
fish 11, 13, 48–49
food mixer 82
fox 24–25
garlic 80–81
giraffe 34
Golden Gate Bridge 58
grey heron 45
guitar 72–73
hedgehog 26–27
helianthus 68–69
helicopter 62–63

hibiscus 21
hippopotamus 32
honeycomb 39
horn 74–75
horse 51
hot-air balloon 62–63
hot dog 77
hummingbird 21
ice-cream sundae 77
Japanese maple tree 41
kangaroo 56
kingfisher 47
koala 57
lamp 71
lemon 80–81
lighthouse 61
lupin 43
mallard 44
measuring jug 83
measuring scales 83
monstera 66
mouse 4–5
mushroom 80–81
oak tree 40
onion 80–81
otter 46
owl 30–31
pagoda 59
parrot 22
pea 80–81
peacock 29
pear 80–81
pelican 14–15
people 84-89
pig 8–9
plum 80–81

polar bear 54–55
postcard 92-95
puffin 14–15
rabbit 52–53
robin 28
rolling pin 83
rose 68–69
saxophone 74–75
scooter 64–65
scuba diver 11
seagull 14–15
snail 36
spider 36
squirrel 26–27
sofa 70
still-life 90–91
String of Pearls 67
sunflower 43
teacup 78–79
teapot 78–79
tomato 80–81
toucan 20, 22–23
trees 40, 41
trombone 74–75
tulip 42
turtle 12
violin 74–75
watermelon 80–81
whale 10–11
whisk 82–83
windmill 60
zebra 35